complete airbrush techniques

for commercial, technical & industrial applications

Sol Dember
Steve Dember
PIERCE COLLEGE, LOS ANGELES

Howard W. Sams & Co., Inc.
4300 WEST 62ND ST. INDIANAPOLIS, INDIANA 46268 USA

To

My wife, Betty, and sons Steve and Jeff

Copyright © 1974 by Howard W. Sams & Co., Inc.,
Indianapolis, Indiana 46268

FIRST EDITION
SECOND PRINTING—1978

International Standard Book Number: 0-672-21119-X
Library of Congress Catalog Card Number: 74-79841

Printed in the United States of America

Contents

Section I
Black and White Airbrush Work

Section II
Color Airbrush Work

Preface

The airbrush is a pen-size art instrument capable of producing a variety of effects for advertising art, photo retouching, and renderings in most phases of the commercial and industrial art fields, utilizing both technical and commercial art. This instrument is used to apply paint in soft gradations ranging in coverage from a fine-blended pencil line to a broad covering stroke, meeting the demands of the artist to blend either colors or black-and-white paint in a manner impossible to duplicate with brush and palette.

The airbrush also is used in industry for producing textile art directly on products for special effects, such as posters, sign painting, greeting-card manufacturers, painting toys, automotive and motorcycle painting, ceramics, and a host of other functions that may not be of particular interest to the professional artist but may have value for factory and hobby use.

The airbrush requires an air supply, such as an air compressor or a carbon dioxide pressure tank, with a gauge for reducing high pressures to a workable pressure of 25 to 35 pounds.

This book deals with a completely workable approach to mastering the techniques required for producing commercially salable photo retouching and renderings accomplished with the airbrush in black and white or in color. The book has been designed with a progression of lessons to aid the novice in learning the complete airbrush operation. It also is a handy reference source for the professional artist, the airbrush artist, and the hobbyist.

In summation, the progression of instructional lessons in this book will enable the beginner to master the techniques of the airbrush from the basics to the most complicated assignments he might encounter in the field. Keep in mind that the two most important factors in mastering the airbrush are a little patience and much practice.

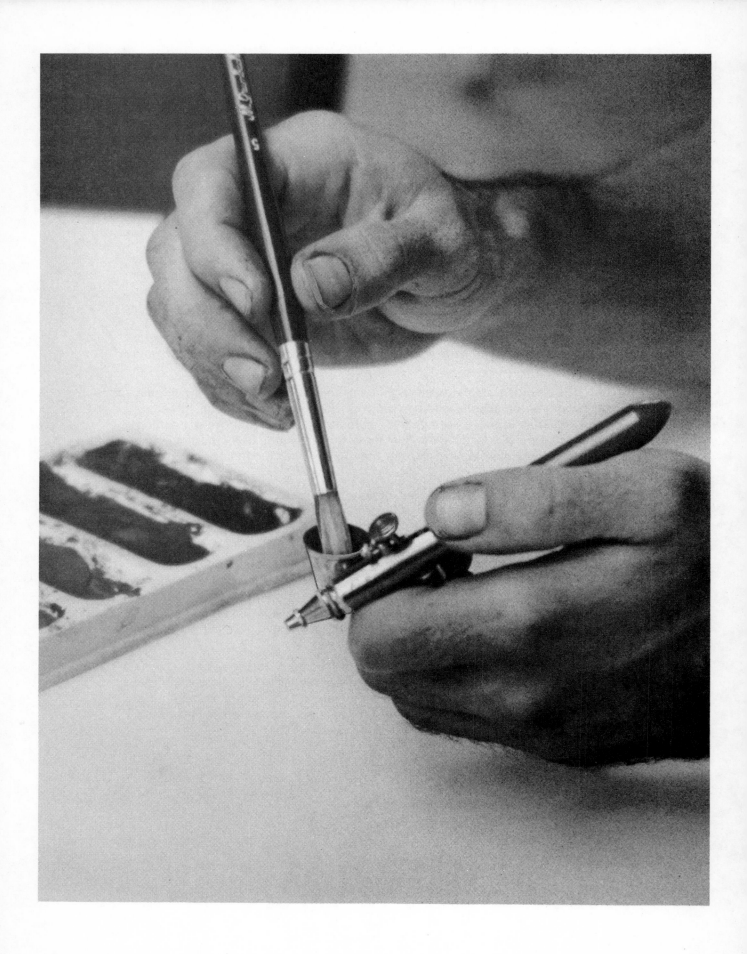

Section I

Black and White Airbrush Work

Topic 1

CHOOSING THE CORRECT AIRBRUSH

The first and most important step you must take is to choose the correct airbrush for the type of work you desire to perform. There are many types of airbrushes manufactured and a smaller number of manufacturers (Fig. 1-1). You must consider the fineness of line, the size of the work to be done, and the materials you will use through the airbrush—whether they will be watercolors, lacquers, enamels, or inks. Basically, each manufacturer makes an airbrush which closely parallels the airbrushes made by other manufacturers for any given job you might attempt.

The airbrushes used by artists generally are in two categories—the double-action and the single-action types. The double-action airbrushes are used with watercolor or thin paints for fine-to-moderately large work, and they produce a variable spray while working—by depressing the finger-controlled front lever for air and by pulling back on the same lever for the amount of color you wish to spray. The single-action airbrushes are used for the heavier spray materials. Depressing the finger lever releases the air, while the amount of color desired is controlled by rotating the knurled adjusting tip for either more or less color. Changing the amount of color you wish to spray while working cannot be done, since you must stop spraying to rotate the regulating tip.

Wold Airbrushes
(Fig. 1-1)

Models A-1, A-2, and A-137 are fine double-action airbrushes capable of all-around studio work, to be used with watercolors, retouch grays, or dyes.

Model Master and Master M airbrushes are heavy-duty, double-action airbrushes which produce a large spray and are capable of using lacquers, enamels, or poster paints.

Models BBF and BBT, double-action airbrushes, utilize an oscillating needle and produce extremely tiny line details for jewelry work and other hairline detail; these airbrushes cannot cover large areas successfully.

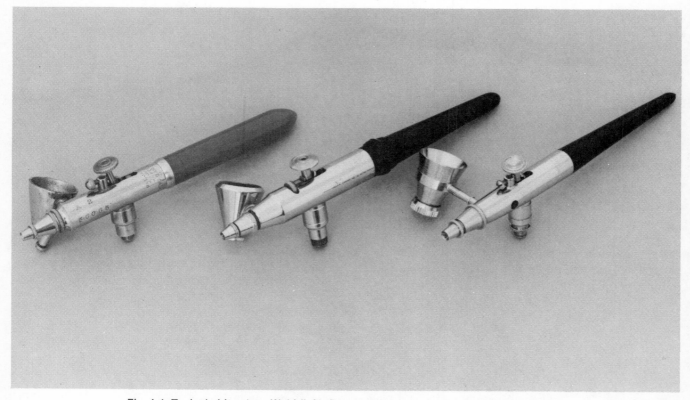

Fig. 1-1. Typical airbrushes. Wold (left); Paasche (center); and Thayer-Chandler (right).

Models U, J, and JN are single-action airbrushes which produce medium-fine work and are slower than the double-action airbrushes, due to the necessity of changing spray width by rotating the knurled adjusting tip.

Models K and KM are large, single-action production-type airbrushes capable of utilizing heavy materials such as lacquers and enamels.

Paasche Airbrushes
(Fig. 1-1)

Model AB is a double-action precision instrument capable of producing very fine lines for extremely delicate artwork, used with watercolors and dyes.

Models V and VL are double-action airbrushes, good for all around studio work, ranging from fine-to-medium sprays, retouching, fine detail, etc.

Models H and F are single-action airbrushes with independent color control at the tip, capable of medium-to-large work and simple to operate.

Thayer & Chandler Airbrushes
(Fig. 1-1)

Model A is a fine, double-action, all-around instrument using water-soluble retouch grays or colors, or water-soluble dyes.

Model AA is a larger, double-action instrument capable of spraying medium-to-large areas.

Model C is double-action, also larger than the Model A, and produces a large spray of watercolor, lacquer, enamel, etc.; it is used for displays, signs, models, and similar work.

Models G and E are single-action airbrushes for general large work.

Badger Airbrushes

Models 100 and 100XF are fine, double-action airbrushes used for general studio work with watercolors, retouch grays, or dyes. Model 200 airbrush is a single-action, heavy-duty airbrush used for large work, and it can handle lacquers, enamels, etc.

Binks Airbrush

The Wren gun is a single-action, inexpensive airbrush; color is controlled by a knurled adjusting tip, capable of spraying lacquer, enamels, or watercolors in a medium-to-large spray.

Topic 2
THE AIR SUPPLY

There are three methods of obtaining air to operate the airbrush (Fig. 2-1):

1. The electrically operated air compressor with a tank and automatic shutoff.
2. The electrically operated compressor with direct flow of air to the airbrush.
3. The carbonic air tank (compressed CO_2).

Also, there are small compressed-air aerosol cans. These are not recommended for any long-duration work, since they are extremely limited in air supply.

The electric compressor is more reliable than the carbonic air tank in that you will not run out of air supply at a time when a refill is not available. They are somewhat noisy, while the carbonic air tank is absolutely quiet.

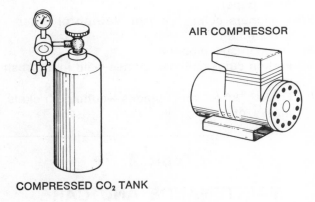

COMPRESSED CO_2 TANK

AIR COMPRESSOR

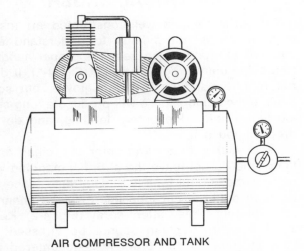

AIR COMPRESSOR AND TANK

Fig. 2-1. Three methods of supplying air to operate an airbrush.

Topic 3

MATERIALS AND EQUIPMENT

The equipment necessary for the airbrush artist, other than the airbrush itself and an air supply, will vary slightly according to the type of airbrush work attempted. The following listing generally will cover most of the items needed to accomplish the job. The use of these items is explained fully in the appropriate section of this book.

1. Acetate or celluloid sheets, 0.005—cutting dry masks
2. Brayer—rolling down photos and mountings
3. "Bridge," ruler or straightedge—brush line work
4. Bristol brush, round—to fill airbrush cup with color and to clean out cup
5. Card stock, lightweight—dry masking
6. Cover paper, nonoily—brown craft paper/bond paper
7. Designers color, Windsor Newton or other—see Section II
8. Desk brush—cleanup
9. French curves/ellipse guides—aid in airbrush work
10. Frisket knife and blades—cutting friskets, masks, etc.
11. Frisket paper, thin—masking areas
12. Kodak watercolor—sheet dyes for photo color work
13. Magnifying glass—checking photos
14. Masking tape—preparing art
15. Palette, plastic or porcelain—with grays or colors
16. Paperweights, flat—holding down dry mask areas
17. Retouch grays, #1, 2, 3, 4, 5—retouching and rendering
18. Rubber cement, dispenser, and pickup eraser—mounting and preparing frisket paper and for cleanup
19. Sable brush, #3 or #4—highlighting and brushwork
20. Sterile cotton—wipeoffs and cleaning photos
21. Stone, sharpening—sharpen frisket knife
22. T square and triangle
23. Tracing pad—sketches to add to artwork
24. Transparent watercolor, Windsor Newton or other—see Section II
25. Transparent watercolor dyes, Dr. P. H. Martin—very transparent dyes
26. Tube paint, intense black or ivory black
27. Water container—with large opening for cleanout purposes
28. Watercolor paint, good-covering white—Miller's brush, Permo white, or other

Topic 4

MAINTENANCE AND CARE OF THE AIRBRUSH

The airbrush is a well-constructed art instrument which is not difficult to understand and, much like a good watch, requires proper handling to provide uninterrupted service (Fig. 4-1). It does not require handling with kid gloves, but some logic and common sense will produce a long service life. Think twice before lending, and do not drop or abuse it.

Keep your airbrush and color cup clean at all times and do not leave the airbrush standing with color in the cup for long periods of time, since this tends to gum the cup and internal feed channels and will cause intermittent spray (Fig. 4-2). Keeping the airbrush clean cannot be stressed too strongly; most of the problems encountered can be traced directly to an airbrush that has not been cleaned properly (Fig. 4-3). The cup should not have any residual color in the bottom or in the attaching stem when you have finished working with it (Fig. 4-4).

If the needle is removed from the airbrush for cleaning purposes, which should be done before putting the airbrush away after using, make sure it is replaced in the airbrush properly and is snug against the tip (Figs. 4-5, 4-6, and 4-7). Do not jam it into the tip.

You will find that a residual stain will remain on the needle. One method of polishing it is to hold the needle flatwise on your worktable; then run a pink eraser the length of the needle (being extremely careful not to bend the tip) while turning the needle slowly by rolling it toward yourself on the top of the table. This procedure will remove all stain and paint particles from the needle body. Be sure to remove all eraser particles by running the needle between your thumb and forefinger from the back of the needle to the tip. When replacing the needle in the brush, be sure to tighten the retaining nut firmly; or "spitting" will occur,

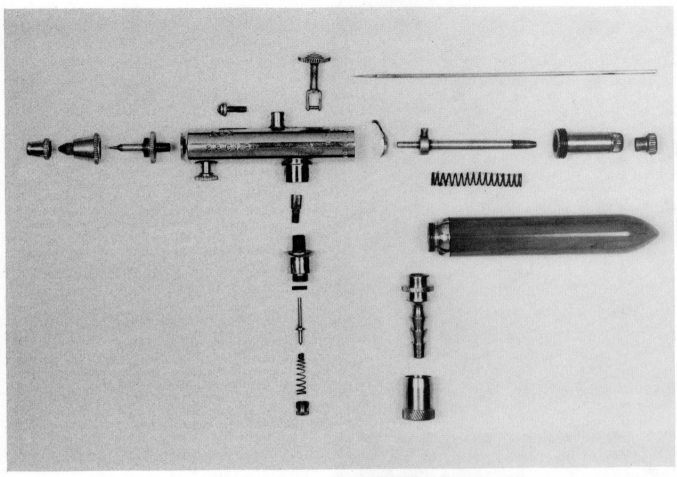

Fig. 4-1. Exploded view of the Model A-2 Wold airbrush.

Fig. 4-2. Cleaning the color chamber. To clean the color chamber, remove the color cup and insert a bristol brush into the hole that the cup fits into, turning the brush to clear the chamber of the paint. Also, the chamber can be cleaned by placing cotton on the end of a reamer, inserting it into the hole and removing the residual paint from the chamber. The latter operation is performed with the needle removed from the airbrush.

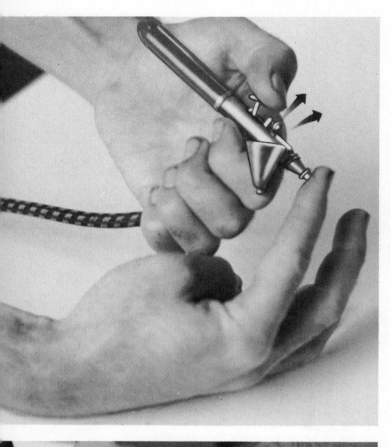

Fig. 4-3. Place a finger on the airbrush tip to back flush. Another method of cleaning the airbrush is to back flush by filling the color cup with clear water, placing the airbrush underneath the tabletop to prevent color splattering your work, and pulling back on the lever while pushing down for full air passage, with your finger covering the tip. This will flush the color backward through the airbrush, clearing and purging any leftover paint from the chamber and cup.

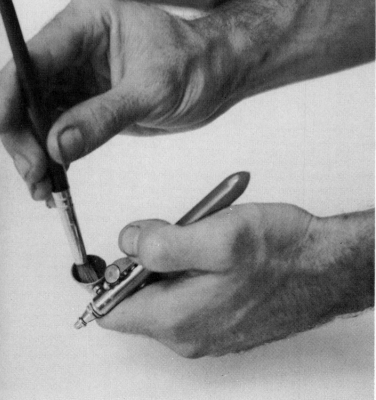

Fig. 4-4. Cleaning the cup. To clean the color cup, use a bristol brush to swirl clean water on the inside surface of the cup; repeat as necessary to clear all color from the cup.

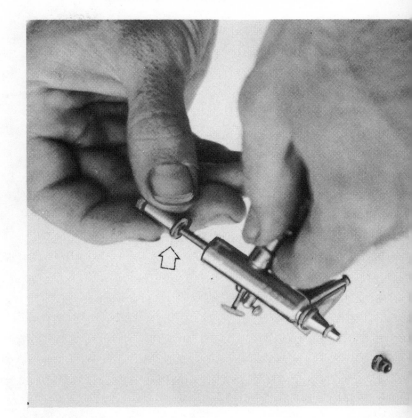

Fig. 4-5. Removing the needle chuck and needle guide bearing. After removing the needle from the airbrush, which is accomplished by loosening the needle chuck and withdrawing the needle straight outward from the back of the airbrush, proceed to turn the needle guide bearing out of the airbrush body by turning in a counterclockwise direction.

Fig. 4-6. Removing the needle chuck guide. Gently pull the needle chuck guide straight outward from the airbrush body.

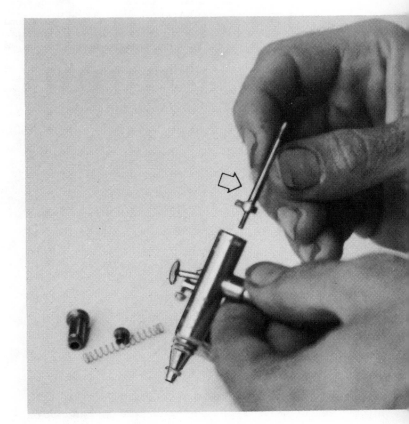

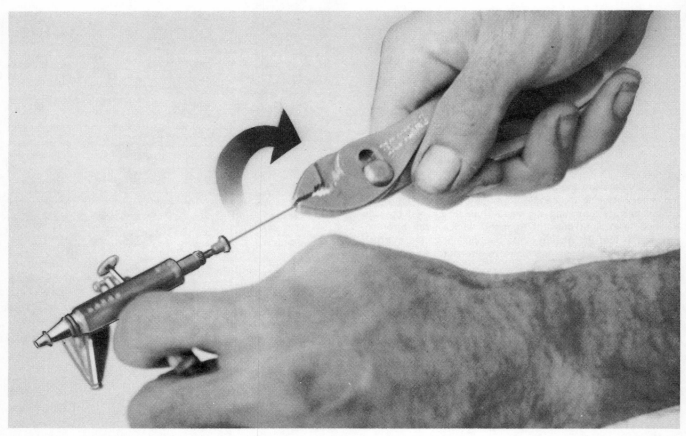

Fig. 4-7. Loosening the needle. If the needle is stuck in the airbrush, use pliers to loosen and remove it. Carefully loosen the needle chuck; then grasp the end of the needle with the pliers and twist in a counterclockwise direction to release the needle. On withdrawing the needle from the airbrush, inspect for the presence of hardened paint, which causes the needle to bind.

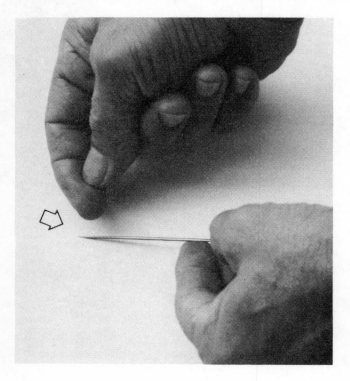

Fig. 4-8. The bent tip of a needle can be straightened.

and you will be unable to shut off the color flow. Always protect the tip of the needle; on some airbrushes, it may project beyond the spray regulator and be susceptible to constant bending. A bent needle will prevent you from airbrushing a fine line and will cause an erratic direction of spray. A bent tip on a needle does not mean that it is to be discarded; by placing the needle on a firm surface at the angle of the tip, you can easily straighten the bent tip by running your fingernail across it on the tabletop, while you turn the needle slowly. Run your fingernail from the body of the needle outward toward the tip (Fig. 4-8).

Keep in mind when you have removed the needle from the airbrush that the back lever on some airbrushes is easily moved out of position, causing difficulty in returning the needle to its proper position, plus the fact that the front lever air control may slip up into the airbrush body and will be difficult to replace (Figs. 4-9 and 4-10). To

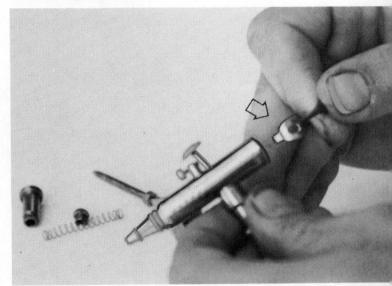

Fig. 4-9. Removing the auxiliary lever. The auxiliary lever can be removed from the airbrush body by means of a tweezer or by gently shaking the airbrush in an upside-down position.

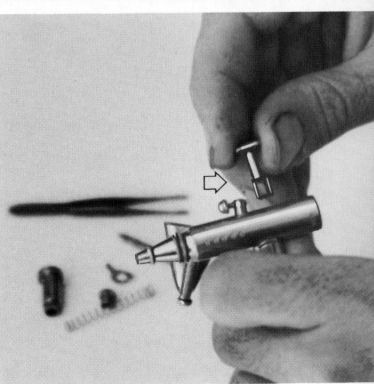

Fig. 4-10. Removing the main lever. The main lever can be lifted up and out of the airbrush body while gently twisting the lever; it fits into a slotted part at the bottom of the airbrush body.

prevent this condition, hold the airbrush in an up-right position (tip up) while the needle is removed.

Permitting the needle to snap back by releasing the front lever too quickly can cause a split tip; this will cause malfunction of the airbrush and will necessitate replacing the tip (Figs. 4-11 and 4-12). With experience, you can replace the tip yourself, depending on the type of airbrush. Some tips are

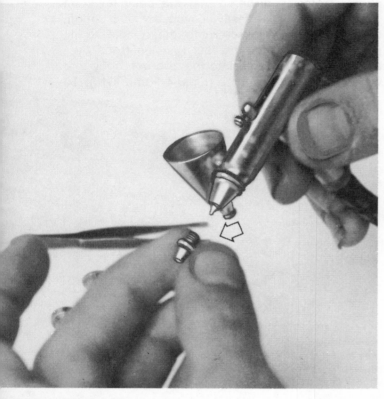

Fig. 4-11. Removing the air cap. The air cap can be removed from the front of the airbrush by unscrewing it in a counter-clockwise direction.

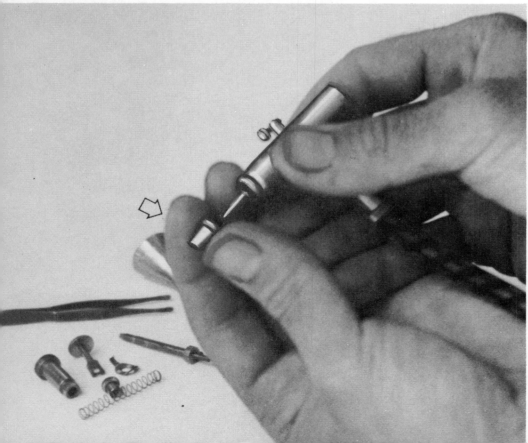

Fig. 4-12. Removing the air head. Pliers might be needed to unscrew the air head, exercising great care, since the knurled edge might be scored; again use a counterclockwise motion.

threaded and are screwed into the head of the airbrush with the aid of a reamer. The threads must be sealed with beeswax, as must the threads on the airbrush head itself. If the head or tip is not sealed with beeswax (a small amount will do), an intermittent spray will occur (Fig. 4-13). Wipe all the airbrush parts with a small amount of light-weight oil.

The valve casing is removed from the airbrush by turning carefully in a counterclockwise direction; pliers should be used to accomplish this action (Fig. 4-14). After the valve casing is removed from the airbrush, remove the inner parts from the casing. Remove the valve nut first; then remove the plunger and spring, and remove the washer last (Fig. 4-15).

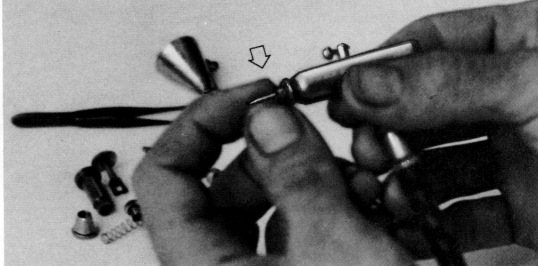

Fig. 4-13. Removing the material tip. Use a counterclockwise motion to carefully unscrew the material tip. Failure to seal this part with a small quantity of beeswax when placing it in the airbrush causes an intermittent spray. Lightly coat the threads with beeswax before engaging them; then tighten firmly.

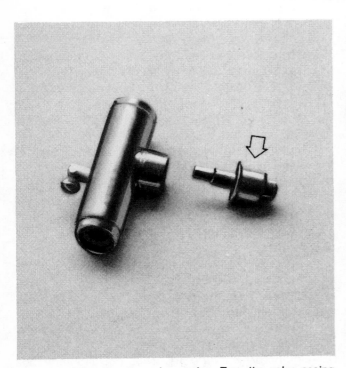

Fig. 4-14. Removing the valve casing. Turn the valve casing carefully in a counterclockwise direction to remove it from the airbrush. The pliers should be used to accomplish this action.

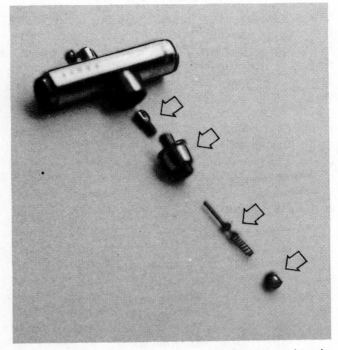

Fig. 4-15. Removing the valve nut, spring, plunger, and washer from the valve casing. After removing the valve casing from the airbrush, remove the inner parts from the casing—first the valve nut, then the plunger, spring, and washer.

Topic 5

THE BLACK AND WHITE PALETTE

The preparation of a palette with graduated watercolor grays, plus black and white, is an important step. There are various types of porcelain or plastic palettes on the market today for preparing the gray-scale retouch paints. Choose a palette that has deep wells, so that you can fill them with a substantial quantity of paint; allow the paint to dry in the palette wells before using, and you will have greater control of the consistency of the paint and the flow of air through the airbrush. If you squeeze out small amounts of paint into a palette, you will be working with wet paint and will find that you will have a grainy spray; also, the spray is different each time. This is caused by the pigments and binder separating in the palette and the cup. This condition causes you to spray pigment through your airbrush at one time and binder at another time. Retouch grays are available, such as Permo grays, Grumbacher retouch grays, Mill-

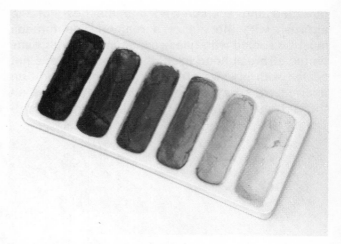

Fig. 5-1. The warm gray palette.

er's "warm" and "cool" grays, etc. If you choose to use warm grays, rather than cool grays, you will find that the reproductions made from your work will be more true in tonal value (Fig. 5-1). There is less reproduction loss from warm grays than from cool grays.

Topic 6

TROUBLESHOOTING

It is advisable for all airbrush artists to know how to take the airbrush apart and to know how to recognize the symptoms of trouble in the operation of the airbrush (Fig. 6-1). A working knowledge of the instrument you are using will enable you to make most part replacements and repairs; but, if you cannot handle mechanical objects, it would be advisable for you to contact the factory or an art supply store for any repairs to your airbrush. Topic 4 (Maintenance and Care of the Airbrush) described in detail the disassembly and reassembly of an airbrush. The following problems will aid in troubleshooting your airbrush.

1. *Grainy spray.* Caused by paint being too thick; add water sparingly to the mixture, check the needle and regulator tip for dried paint, and check the air supply.
2. *Buckling paper.* Paint may be too thin; add pigment to thicken the mixture. Do not airbrush as heavily in one area; move more rapidly or lessen your spray.
3. *Paint blobs at ends of stroke.* You are spraying paint before moving your hand and stopping the movement before shutting off

the paint flow. This is explained later in Topic 7 (Airbrush Handling).
4. *Flared ends.* Caused by turning the wrist while airbrushing; the whole forearm should move horizontally across the paper.
5. *Centipedes.* Caused by spraying too much paint from too close to the paper. If a fine line is desired, lightly pull back on the front lever.
6. *Splattering.* Caused by permitting the needle to snap back into the tip. Always release the lever gently. Check for dried paint on the needle or tip.
7. *Curved stroke.* Caused by arcing arm too close to the paper; the arm should always be parallel to the paper while working, unless this effect is desired.
8. *Restricted spray.* Can be caused by regulator tip being screwed too tightly into the head; back up a few turns.
9. *Bubbles through color cup.* The spray regulator tip might be turned out too far; turn it back in a few turns. The color cup stem may be partially clogged.
10. *Color spray cannot be shut off.* Tip may be clogged; this is recognized by a "spongy" feel when the needle is set into the tip. A reamer can be used to clean out the dry,

gummy color in the tip by pushing it gently into the tip, removing the reamer gently, turning the reamer, and pushing it gently back into the tip. Repeat this maneuver until the residue is pushed out of the tip. Run clear water through the airbrush and repeat as necessary. Take extreme care of the tip and the needle throughout this operation.

11. *Spitting.* Caused by residue on the needle or in the color cup. Keep your airbrush clean at all times. Paint may be too thick to operate properly.

NEVER WRITE OVER A PHOTOGRAPH—the impression may be picked up when the photograph is recopied or printed.

Fig. 6-1. Troubleshooting.

Topic 7

AIRBRUSH HANDLING

The normal setup for preparing commercial or industrial art is used for the practicing airbrush artist. This is a sufficiently large adjustable drawing table, taboret, comfortable chair, adjustable floating lamp, color palettes, water jug, brushes, and airbrush hanger, airbrush, and air supply. Keep a comfortable position relative to your work at all times. Do not cramp yourself or force your working position.

Normally, you will find in the airbrush case the airbrush, a protector for the tip, a cup, a hanger, a hose coupling, and perhaps a spare needle. If you purchase a hose length without the airbrush hose coupling and air supply coupling, the couplings are easily installed on the hose. Wet the inside of the tube end and insert the coupling into the hose with a twisting motion. The couplings may require a twist of wire around the hose to secure the fitting. With one end of the hose attached to the air supply (CO_2 tank or compressor), the airbrush is gently turned into the hose fitting (Fig. 7-1). Then the air is regulated to a

Fig. 7-2. Air regulator and usable pressure.

pressure of 25 to 35 pounds by slowly turning the regulator control lever in a clockwise direction until the needle on the gauge shows the desired pressure (Fig. 7-2). Remove the needle gently and check the tip (Fig. 7-3); then reseat the needle, tightening the locknut firmly. Attach the color cup by inserting the stem into the hole at the side of the airbrush near the head. Twist the stem in firmly, allowing the cup to tilt toward you at about a 30° angle (Fig. 7-4); this will prevent spillage of paint from the cup while holding the airbrush perpendicular to the work. Run some clear water through the airbrush to remove any possible leftover material.

If you are right-handed, allow the hose to take one twist around the right forearm by grasping the airbrush in the left hand and making a loop around the right wrist (Fig. 7-5); then pass the airbrush to the right hand (Fig. 7-6). This twist of the hose will prevent your dragging the hose across your work accidentally while working on a drawing. The left-handed artist will, of course, do the same with the left forearm.

The correct movement for producing accurate control on the operation of the airbrush is de-

Fig. 7-1. Attaching the airbrush to the air supply hose.

scribed in the following paragraphs. This motion should be adhered to carefully during your early lessons, and it will become second nature to you when you become proficient in the field.

Paint is applied to the cup by means of a bristle brush (Fig. 7-7). The paint consistency is softened and prepared in the palette and transferred to the

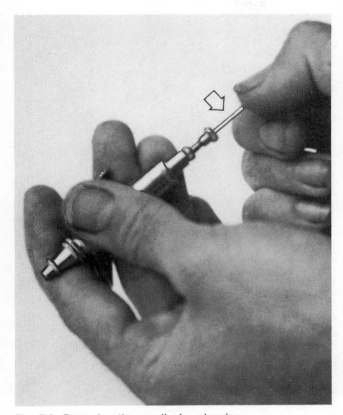

Fig. 7-3. Removing the needle for cleaning.

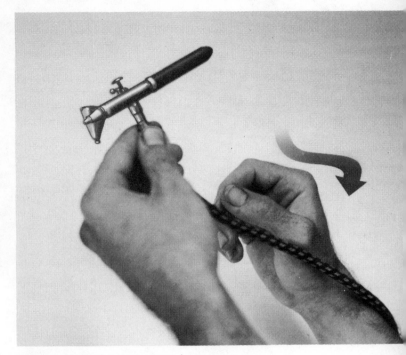

Fig. 7-5. Wrap the hose around your arm.

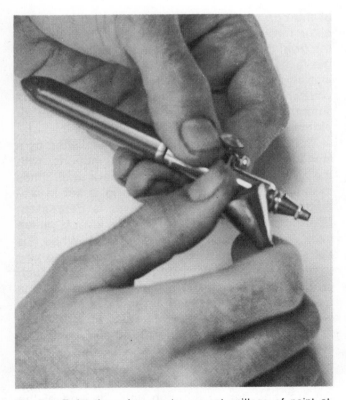

Fig. 7-4. Twist the color cup to prevent spillage of paint at the angle of the airbrush.

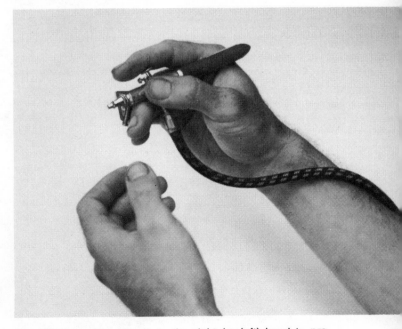

Fig. 7-6. Pass the airbrush to the right (or left) hand to prevent dragging the hose across the work.

cup; you can mix the paint in the cup. The consistency should be such that it will tint the brush, but not color the brush solid with color. A good clue to the paint consistency is that it should stick to the sides of the cup, but not thickly color the sides

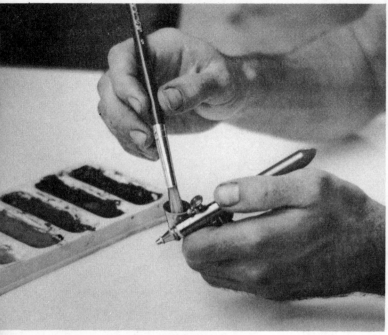

Fig. 7-7. Fill the cup with color.

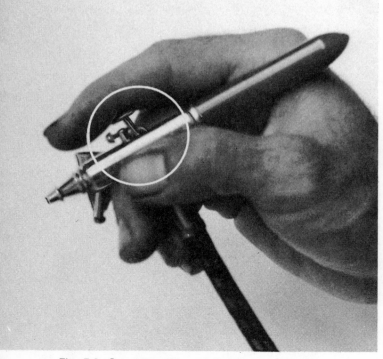

Fig. 7-8. Correct position of the control finger.

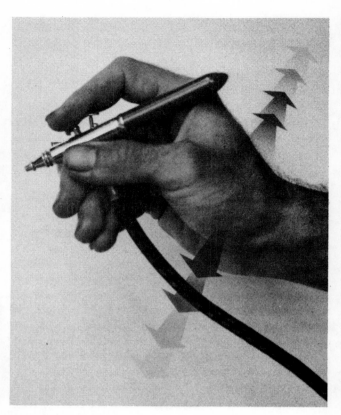

Fig. 7-9. Arm motion.

of the cup. On a piece of scrap paper, run some color through the airbrush by *pressing down* on the front lever control for air—and *pulling back* on the lever for color—just to obtain the feel of the instrument (Fig. 7-8). Experimentation will provide you with the exact consistency desired for the smoothest tones by alternately adding water or pigment until a balance is accomplished.

The stroke of the airbrush is accomplished by a smooth transition of three distinct motions, with the airbrush perpendicular to the work at all times to minimize overspray: (1) The arm is set in motion (Fig. 7-9); (2) The front lever is depressed, releasing air only (Fig. 7-10); (3) The lever is pulled back gently, releasing color (Fig. 7-11). When this action is mastered, you will have gone a long way toward becoming proficient in this field. Much practice is necessary to achieve this end. Set the front lever in the first joint of the index finger (see Fig 7-8), not on the ball of the forefinger itself; it is more comfortable there and the control is more absolute. You can increase the flow of color merely by bending the forefinger in a beckoning manner, allowing minute increases in flow. Keep the arm and hand in motion until the end of the stroke approaches (Fig. 7-12). At that time, the

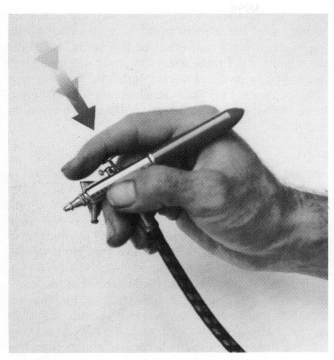

Fig. 7-10. Depress the front lever, releasing air only.

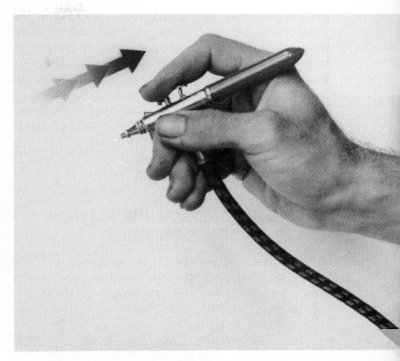

Fig. 7-11. Pull back gently on the lever to release color.

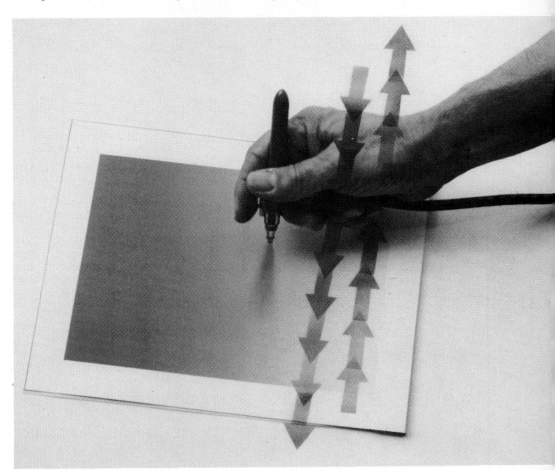

Fig. 7-12. Airbrush motion.

procedure reverses so that you now move the lever forward slowly, shutting off the flow of color; then release the lever upward, shutting off the air flow and, finally, stopping the motion. Although these three actions are separate, they should follow each other closely and smoothly in a steady motion. If the three motions were done simultaneously, a rush of paint would occur, causing a prob-

able "centipede" effect. Remember the action is steady and the arm is parallel to the paper with no twist of the wrist. Practice the steps: (1) Hand in motion; (2) Press down the lever (air); (3) Pull back gently on the lever (color), and now reverse the procedure; (4) Push lever gently forward (stop color flow); (5) Let up gently on the lever (stop air flow); and (6) Stop motion.

Topic 8

BASIC EXERCISES AND TECHNIQUES

The distance between the airbrush and the paper, and the distance that you pull back on the front lever determine the broadness of spray you will receive.

Airbrush Line Exercise (Lesson 1)

On a blank sheet of paper, lightly rule several parallel pencil lines across the sheet, about 2

inches apart. Holding the airbrush tip about 4 inches from the sheet, airbrush a broad line from left to right, using the pencil line as a guide and following the 1-2-3 motion described earlier (Fig. 8-1). Release paint, air, and motion at the end of the stroke. Now, start backward from right to left, ending with the same release paint, air, and motion. When the sheet of broad strokes is completed, do a sheet of medium strokes with the airbrush 2 inches from the paper and with the lever pulled back a shorter distance. Finally, do a sheet of fine lines, holding the airbrush 1 inch from the paper and pulling back on the front lever very gently, for a small spray. Do not spray over a line more than one time. Continue this lesson until you

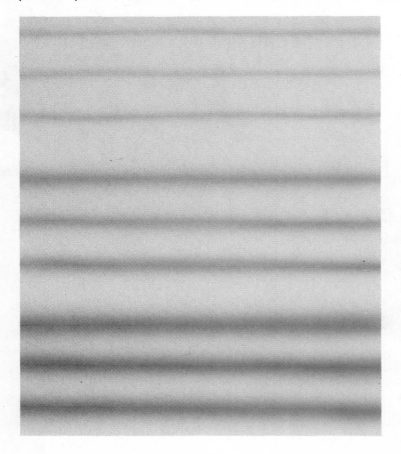

Fig. 8-1. Practice airbrushing fine, medium, and broad lines on a sheet of paper.

Fig. 8-2. Practice airbrushing curved lines.

feel you can master the airbrush line; it will prove beneficial to you later in your work. Now, try curved airbrush line work in the same manner (Fig. 8-2). Keep the line consistent in thickness and density.

Brush and Bridge
(Lesson 2)

In combination with the airbrush and its soft smooth-appearing finish, there is the little-mentioned matter of brushwork. Mastering the brush and bridge to enhance and finalize a photo retouching or an airbrush rendering, whether it is in black and white or in color, cannot be dwelled on too heavily. A #3 or #4 Windsor/Newton sable series #7 brush or similar brush is necessary, plus a bridge or mall stick or a straightedge device to guide and rest the brush against, while highlighting or shadow striping a piece of art (Fig. 8-3). Practice ruling straight lines or slightly curved lines by holding the left-hand end of the bridge firmly

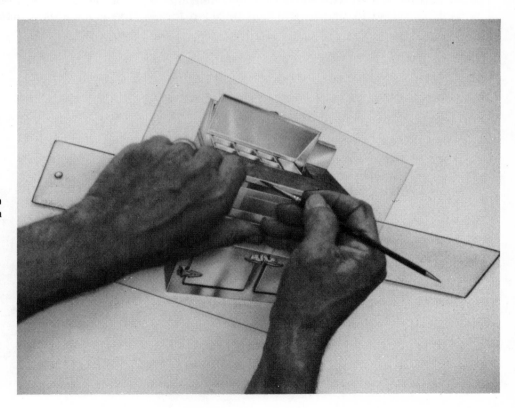

Fig. 8-3. Use a bridge and brush in highlighting or shadow striping a piece of art.

with the left hand and resting the hand on the knuckles while the ferrule (the metal part of the pointed brush with the paint) rests against the upper edge of the bridge and the fingernail of the middle finger of the right hand guides against the same upper edge of the bridge. The thickness of line is controlled by varying the height of the bridge edge above the work by rolling the left hand on the knuckles forward or backward. To check the accuracy of the line you are going to brush in, draw the brush across the work without touching the tip to the surface. If your line is accurate, paint the line in the manner described. If it is not accurate, move the bridge until it is accurate; then complete the brush line. Knowledge of this line technique, coupled with later lessons, will enable you to accomplish realistic renditions of chrome, wood, cork, etc.

Friskets and Masking Devices

Working with the airbrush necessitates the knowledge and use of masking methods and materials. There are friskets—prepared and unprepared—dry masks, and masking liquids which can be used. *Friskets* are used to mask out an area while airbrushing another area. Any thin tracing paper can be coated with rubber cement, and the cement permitted to dry; then it can be used for

a frisket. It is more difficult to cut out accurate detail with a frisket knife on tracing paper than on a thin frisket paper manufactured specifically for that purpose; but, it will work. If you use tracing paper, you will find that you are required to cut deeper and may, therefore, score your work with the frisket knife, thereby developing a habit that might be difficult to overcome. Asco frisket paper, thin, is generally used. Do not obtain more than a few months supply, since the paper may become discolored and brittle. A number of "prepared" frisket papers are on the market; but, they have proven to be generally unsatisfactory.

Preparing Frisket Paper

Place a sheet or a portion of a sheet, along with the backing paper, on a card or in an old photo box for protection and reuse. Tape down the corners and coat with two thin coats of rubber cement, applying one coat at a time (Fig. 8-4). Permit each coat to dry. When dry, the surface will appear shiny when viewed at an angle. Do not use rubber-cemented frisket paper while wet, since it will leave a residue and cause problems. When the frisket paper is dry and ready to use, cut out a piece of paper slightly larger than the area to be airbrushed. Turn it over carefully, so that it does not fold on itself; then place the frisket paper over the work area. Smooth the frisket paper with the

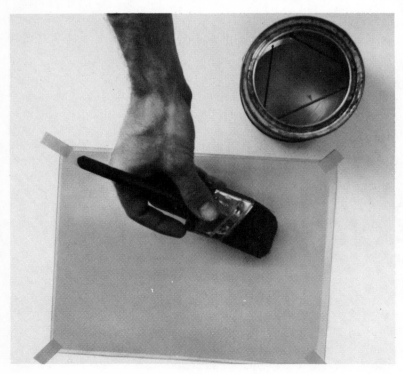

Fig. 8-4. Preparing a frisket paper.

Fig. 8-5. Cutting frisket paper with a frisket knife.

hand, trying to avoid forming folds or creases, since these will form a small pocket and allow underspray. Gently, cut out the area to be painted, trying to avoid scoring the work underneath. Lift the corner of the frisket paper with the knife and remove the frisket paper. At this point, make sure there is no residual rubber cement on the job, especially around the edges. Airbrush the work and remove all the remaining frisket paper, making sure to remove any dried rubber cement from the work. Prepared friskets are preadhesive and ready to work with; but some papers have a tendency to stick too tightly and remove the airbrush surface. It will be necessary to use rubber cement frequently, and it is advisable to obtain a 1-pint or 1-quart dispenser with at least a 1-inch brush or larger. The use of a small brush will remove as much rubber cement as it will dispense, and you will have uneven adherence.

A good frisket knife with small replaceable blades and a sharpening stone and rubber-cement pickup are required (Fig. 8-5); *always keep your knife sharp.*

Dry Masks

When a simple mask is needed to shield an area from overspray, it can be made from heavy paper, thin paper, card stock, or acetate sheets. Many artists use only dry masks made up of pre-designed acetate sheets in the shape of curves and ellipses. If you intend to make universal dry masks out of 0.005 acetate sheet stock, the shape shown in Fig. 8-6 might be of help. This mask, called a "cow" or "caterpillar," is extremely useful. A set of three will be quite useful in retouching and rendering. The 0.005-in. acetate sheet is placed over the shape, and the outline is scored with a sharp-pointed instrument; then it is snapped along the score line and the edge is sanded lightly. It is now ready for use. Keep it clean, since you can reverse it for later use; a surface with some spray paint on it might scratch your finished work. A small ellipse guide is helpful in airbrushing screw heads, holes, patterns, etc.; the ellipses range from 15° to 60° in various sizes (Fig. 8-7). When using dry masks, you should always have flat weights available to use as hold-downs; type slugs or small weights with flat bottoms are excellent for this purpose (Fig. 8-8). Always airbrush "away from" the edge of the dry mask; or you may obtain a fuzzy edge from the underspray (Fig. 8-9). The soft, fuzzy edge might be desirable in a portrait refurbishing job, rather than have a hard edge around the head of a person.

Acetate dry masks or stencils can be made to fill a specific need in a similar fashion, as de-

Fig. 8-6. A caterpillar-shape dry mask.

Fig. 8-7. Ellipse guides.

scribed earlier for making a cow mask. Place the acetate over the area, carefully score the shape with a sharp instrument or the back of a frisket knife, and snap it out; then sand lightly.

For masking purposes, there are several liquid masking materials that are brushed on. These materials generally are used on photographs, since the surface is hard and the material will peel off easily. A fine brush is used, but it must be cleaned

Fig. 8-8. Type slugs or flat weights can be used for hold-downs.

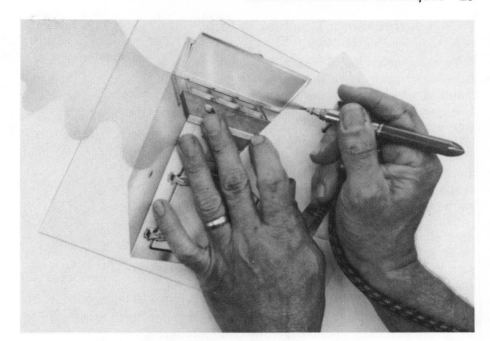

Fig. 8-9. Airbrush "away from" the edge of a dry mask.

well or it will harden. The area to be masked is painted out with this material and allowed to dry; then the retouching is done around it. When the retouching is finished, a corner is lifted and the material is peeled off and discarded. The liquid masking materials are called "Pink Peel," "Mask-oid," "Liquid Frisket," etc.; and they are available in art supply stores. The wipeoff method is an-

other method of removing overspray if a frisket or mask is not used. Sharpen the wood end of a brush, wrap a small amount of sterile cotton around the sharpened brush end, and by slightly wetting the cotton with saliva, you can remove any overspray from an area (Fig. 8-10). Roll the cotton end of the brush so that you lift the paint, instead of smearing it.

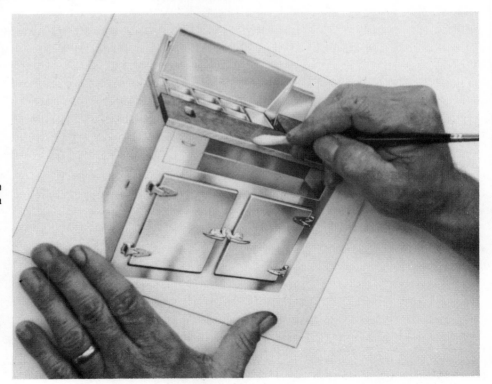

Fig. 8-10. Removing overspray with cotton on the sharpened end of a brush.

Airbrushing The Flat Wash (Lesson 3)

To accomplish the flat wash, we will airbrush a flat tone of gray, using a #3 gray. To prepare the material, use a 1-inch masking tape on the edges of a sheet of bristol or cover stock to minimize the warping which will occur if you used paper stock (Fig. 8-11). Place the masking tape all around the outer edge of your paper stock, pressing down on the inner edge only, to prevent overblow, that is, seepage of tone under the tape edge. Follow the instructions of the 1-2-3 motion (see Topic 7) by airbrushing a fine consistency of paint from left to right at the top of the page, holding the airbrush about 4 inches from the surface of the sheet; be sure to spray a portion of the tape so that no light line shows when the tape mask is removed (Fig. 8-12). Using the 1-2-3 motion (see Topic 7) throughout this lesson, now airbrush from right to left, overlapping the previously airbrushed strokes; continue down the entire sheet, trying not to create a line pattern with the airbrush strokes and overspraying the tape at the bottom of the page. Begin at the top again, and do the entire page again. Repeat the exercise until you reach the desired smooth coverage of the entire page. Do not attempt to cover the entire sheet with a heavy tone

at one time; build the tone gradually (Fig. 8-13). Make sure the work and tape are dry before removing the masking tape; this should be done

Fig. 8-12. Airbrush from the top of the page.

Fig. 8-11. Use 1-inch masking tape on the edges to prepare a sheet of material for a flat wash. This minimizes the warping which occurs with paper stock.

Fig. 8-13. Do not attempt to cover the entire sheet with a heavy tone at one pass down the page. Build the tone gradually.

carefully to avoid tearing the surface of the paper it is adhered to (Fig. 8-14). If your first results are not satisfactory, repeat the lesson until you are satisfied (Fig. 8-15). Remember, airbrush control is strictly a matter of practice.

Airbrushing The Graded Wash (Lesson 4)

This lesson is similar to the previous one, differing in that it will be graded dark at the bottom to a fade-out white at the top. The bristol board is prepared in the same fashion as the flat wash; but the tone used will be a #4 gray, and the exercise will begin at the bottom of the sheet, working upward to the top (Fig. 8-16). Again using the 1-2-3 motion (see Topic 7), we begin gradually airbrushing at the bottom, making sure to overspray the tape—starting from left to right on the first stroke, then right to left, etc. Before you are two-thirds the distance up the page, which you can mark on the tape with a pencil, you begin gradually to fade into the white of the board (Fig. 8-17). Do not fade abruptly and do not carry your tone further than the two-thirds to three-fourths mark on the page. Remember that you will have to repeat this procedure three or four times, and each time you airbrush tone. Starting from the bottom, you must stop your tone shorter than each of the previous applications, since the overspray will build up and

Fig. 8-15. Finished airbrush wash.

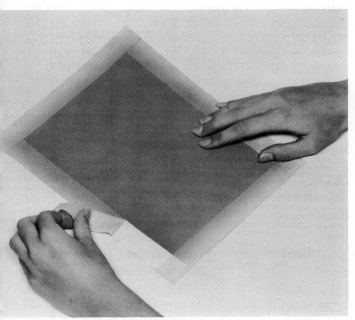

Fig. 8-14. Make sure the work and tape are dry before removing the masking tape.

Fig. 8-16. Airbrush "from the bottom" of the page for a graded wash.

you will not notice it until you remove the tape mask (Fig. 8-18). Now proceed to remove the tape mask carefully (Fig. 8-19).

Fig. 8-17. Airbrush two-thirds the distance up the page.

Fig. 8-18. Make each airbrush stroke shorter.

Fig. 8-19. The finished airbrush graded wash.

Spotlighting
(Lesson 5)

Spotlighting has many uses. In photo work a border might be desirable to hold an edge, or it might be used in reverse; it might be desirable to fade-out an edge of a photo or a piece of art. Spotlighting is achieved by masking the area to be worked with tape or other mask; secure the mask so that it will not move and proceed to airbrush toward and across the corners with most of the tone being deposited on the mask, rather than on the work (Fig. 8-20). Airbrush your light colors first; then airbrush the darker colors as you move toward the corner edge (Fig. 8-21). Do each corner in like fashion, making sure to fade gradually and keeping the center of the area comparatively free from airbrush spray. You will always find it more successful to airbrush away from the object—that is, airbrush toward the corner to minimize overspray.

Soft Handling the Cube, Sphere,
Cone, and Cylinder
(Lesson 6)

Rendering these basic forms will provide instruction and sequence in shading these shapes, which really cover all of the shapes you will en-

Fig. 8-20. Spotlighting the corners.

Fig. 8-21. Final spotlighting.

the soft handling of these basic forms. All these forms can be done on a single piece of board, one at a time. A pencil outline of these shapes is necessary.

Cube (Soft)

Make the line drawing of a cube, as seen below the horizon (Fig. 8-22). The surface farthest from the light source will be the darkest, since it is in shadow. Lightly cut a frisket for the outline and dividing lines of the separate sides at this time, but remove the frisket from the side farthest from the light source only (Fig. 8-23). With the #4 gray pigment in the airbrush, gradually airbrush your paint in a flat wash from the upper right-hand corner downward to the lower left-hand corner. Then, using black paint, gradually airbrush lightly across from the uppermost left-hand corner gradually downward toward the middle of the dark side. Repeat the gradual dark tone as necessary, to achieve a dark-to-black effect on this side (see Fig. 8-23). The next darkest side is the lower left-hand side (Fig. 8-24). Remask the finished side with a small piece of frisket and remove the frisket from the lower left-hand side. To keep a high-contrast appearance to the inner corner, gradually airbrush a #3 gray from the center of the top portion in a sweeping diagonal, downward to the left-hand lower corner, making the bottom right-hand corner the lightest corner of this side; repeat as necessary, to achieve a soft-graded wash.

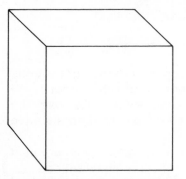

Fig. 8-22. Pencil drawing of the cube.

The remaining upper side facing the light source will be the lightest side, but consideration must be given the outer edges, which must separate from the white background when the frisket is removed (Fig. 8-25). Remove the frisket from the upper side and remask the lower left-hand side. To maintain a holding edge when the frisket is removed, a #2 gray is airbrushed diagonally across

counter; combinations of these forms make up all of the various products and manufactured items. Actually, there are two distinct handlings of the airbrush which we will refer to as "Soft" and "Hard." The soft handling utilizes only the airbrush, giving a soft blended look which is used in natural objects, such as wood, rubber, paper, soft-finish metals, etc. While the hard handling utilizes a combination of both airbrush and brushwork softened with the airbrush, giving a hard to medium-hard appearance to objects such as chrome, polished aluminum, glass, etc. Always strive to achieve a realistic appearance in the work you are doing, and you will have little trouble selling your artwork.

In rendering these shapes, it is a general rule to have the light source coming from the upper left-hand corner at about 45°. Lesson 6 deals with

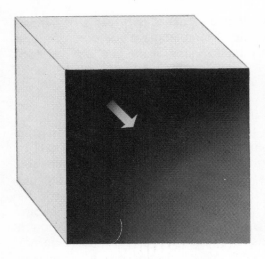

Fig. 8-23. Airbrushing the dark-tone panel.

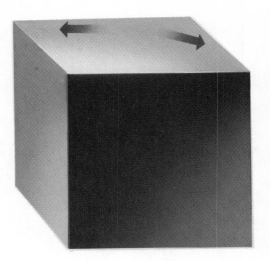

Fig. 8-25. Airbrushing the highlight-panel.

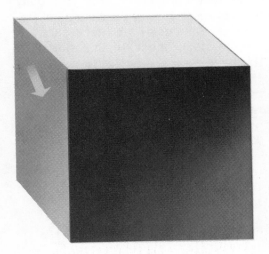

Fig. 8-24. Airbrushing the middle-tone panel.

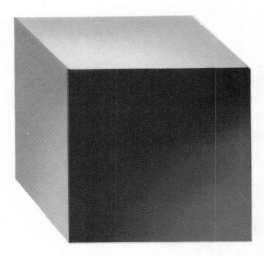

Fig. 8-26. Finished airbrushing of the soft cube.

the corner nearest the upper left-hand light source, while blowing a light tone across the upper right-hand and upper left-hand edges. Remove the frisket and note the three-dimensional appearance of the cube (Fig. 8-26).

Note: Remember that your values will appear much lighter with the frisket on than they will appear with the frisket removed.

Sphere (Soft)

Light source is from upper left-hand corner. First, you must spin a circle with a compass, and place a frisket over it, making sure the remaining portion of the board is not exposed to airbrush overblow (Fig. 8-27). Carefully cut out the circle either by placing a compass knife in the pencil portion of the compass or by freehand cutting

very carefully with a frisket knife. Remove the frisket from the circle, and gradually airbrush a #3 gray lightly around the entire edge of the circle in a curved, rocking, back-and-forth motion, with short smooth strokes (Fig. 8-28). Remember the 1-2-3 motion (see Topic 7). Next, in a curved motion from the bottom right-hand portion of the

Fig. 8-27. Pencil drawing for airbrushing a sphere.

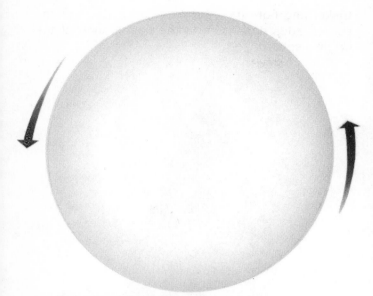

Fig. 8-28. Airbrush around the edge of the circle.

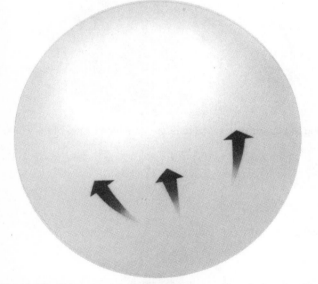

Fig. 8-29. Airbrush upward toward the center, but not quite reaching the center of the circle.

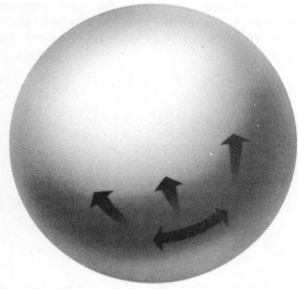

Fig. 8-30. Airbrush dark tone above the reflection.

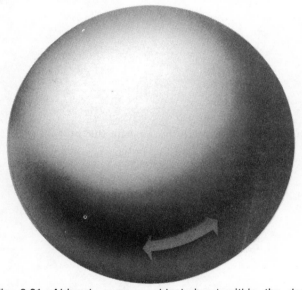

Fig. 8-31. Airbrush a narrow black band within the dark crescent-shaped area.

circle, airbrush upward toward the center—not quite reaching the center (Fig. 8-29). Allow a highlighted circular portion of the sphere near the upper left-hand portion. To achieve the appearance of a sphere, also allow a band of reflected light at the bottom, directly opposite the source of light, by using #5 gray and gradually airbrushing in a crescent motion about ¼ inch above the lower edge of the sphere, covering approximately one-third the circumference of the lower portion of the sphere (Fig. 8-30). The sphere is now acquiring a three-dimensional appearance; to emphasize the reflected light, use a black in the airbrush and

Fig. 8-32. Line drawing of a cone.

gradually airbrush only within the dark crescent-shaped area. Darken the area further with short strokes and fine spray (Fig. 8-31). Remove the

frisket and note how the reflected surface of the sphere adds dimension to the appearance of the original sphere.

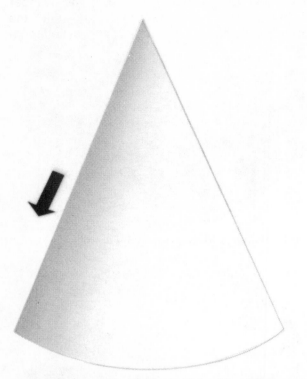

Fig. 8-33. Lightly airbrush the highlight side of the cone.

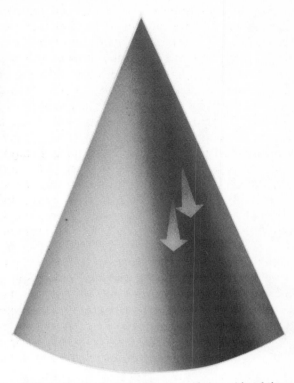

Fig. 8-35. Airbrush black tone on the shadow side of the cone.

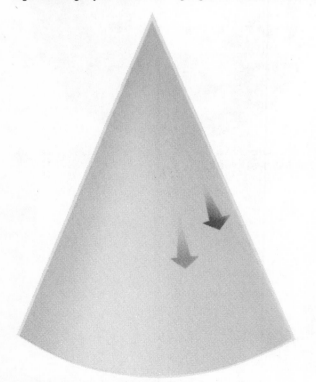

Fig. 8-34. Airbrush the shadow side of the cone.

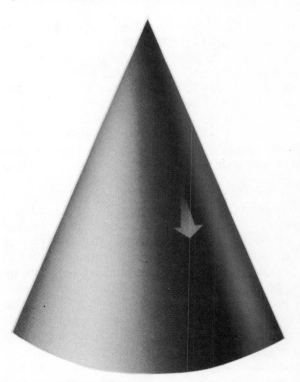

Fig. 8-36. Finished airbrushing of the soft cone.

Cone (Soft)

Make a pencil drawing of a cone with both sides equal and a curved line connecting the tapered sides (Fig. 8-32). Lightly cut a frisket and remove the cone shape, being careful to protect the rest of the board from overblow. Considering the upper left-hand light source, gradually airbrush a #3 gray in a narrow area down the left-hand side of the cone—starting all the airbrush action at the top point of the cone and flaring slightly toward the curved base (Fig. 8-33). Repeat this action on the right-hand side of the cone; this side will be gradually airbrushed from the top of the cone straight downward to the base and flaring to the left-hand side (Fig. 8-34). Remember to follow the cone shape from the top and flare out at the base; the only perpendicular line will be down the center. A highlighted graduated band of light should remain on the left-hand portion of the cone. Now, using black in the airbrush, start at the top of the right-hand side and permit a tapered area beginning at the point and ending ¼ inch inward at the base; blow a gradual tone of black down the cone (Fig. 8-35). This reflected light area will help visually to turn the cone. Remove the frisket and note the tapered appearance of the cone (Fig. 8-36).

Cylinder (Soft)

Draw two horizontal parallel lines of any desired length with approximately one to two inches of space between; then connect the ends of the lines to form a rectangular box (Fig. 8-37). Place a frisket over this shape and cut out the rectangle, being careful to protect the rest of the board from overspray. With #3 gray in the airbrush, gradually airbrush the upper area of the cylinder with a horizontal spray slightly below the frisket edge (Fig. 8-38); the overspray will create a holding edge when the frisket is removed. Using the same tone, horizontally airbrush the bottom portion of the cylinder about two-thirds the distance up (Fig. 8-39). Then, using black and allowing a reflected light area about ¼ inch from the bottom, gradually

build a dark band across the cylinder (Fig. 8-40); remove the frisket and note the reflected light at the top of the cylinder in comparison to the reflected light at the bottom (Fig. 8-41). The cylinder shown in Fig. 8-42 is viewed from an angle; the more the view toward the end of the cylinder in-

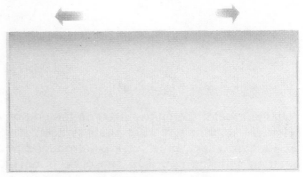

Fig. 8-38. Airbrush the top of the cylinder.

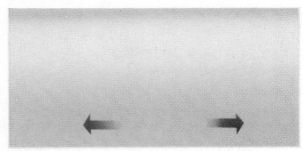

Fig. 8-39. Airbrush the bottom of the cylinder.

Fig. 8-40. Airbrush dark tone above the reflected area.

Fig. 8-37. Line drawing of a cylinder.

Fig. 8-41. Finished airbrush of the soft cylinder.

Fig. 8-42. Isometric rendering of a cylinder.

creases, the greater the ellipse used on the end of the cylinder—until only a 360° circle is seen. To produce a hard effect, brushwork is introduced in combination with the airbrush. The cube is basically handled in the same manner, except that brushwork is utilized before the airbrush is used, as indicated in the following copy.

Hard Handling
(Lesson 7)

Cube (Hard)

Make the line drawing of a cube as seen below the horizon; the surface farthest from the light source will be the darkest, since it is in shadow (Fig. 8-43). Lightly cut a frisket for the outline and

Fig. 8-43. Line drawing of a cube.

dividing lines of the separate sides at this time, but remove the frisket from the side farthest from the light source only (Fig. 8-44). With the #3 sable brush and using #4 gray, paint in a free form shape; fill the upper left corner, curving down between the left and right vertical sides. Then, with the #4 gray tone in the airbrush, gradually overspray your paint in a flat wash from the upper

left-hand corner down to the lower right-hand corner. Using black paint, gradually airbrush lightly from the uppermost left-hand corner diagonally downward toward the middle of the dark side. Repeat the gradual dark tone, as necessary, to achieve a dark-to-black effect on this side. The next darkest side is the lower left-hand side (Fig. 8-45). Remask the finished side with a small piece of frisket and remove the frisket from the lower left-hand side. Using #3 gray, brush in your color

Fig. 8-44. Airbrushed dark side of a hard cube.

Fig. 8-45. Airbrushed middle tone side of a hard cube.

Fig. 8-46. Airbrushed highlight top of a hard cube.

from the upper left-hand corner of this side, curving downward toward the right-hand corner and fill in the area to the left. To keep a high-contrast appearance to the inner corner, gradually airbrush a #3 gray from the middle of the top portion in a sweeping diagonal, downward to the lower left-hand corner, making the bottom right-hand corner the lightest corner of this side; repeat as necessary to achieve a softly graded wash.

The remaining upper side facing the light source will be the lightest side (Fig. 8-46). This side is handled identically to the soft handling; but consideration must be given the outer edges, which must separate from the white background when the frisket is removed. Remove the frisket from the

upper side and remask the lower left-hand side. To maintain a holding edge when the frisket is removed, a #2 gray is airbrushed diagonally across the corner nearest the upper left-hand light source, while blowing a light tone across the upper right-hand and upper left-hand edges. Remove the frisket for the hard cube.

Sphere (Hard)

Light source is the upper left-hand corner. First, spin a circle with a compass and place a frisket

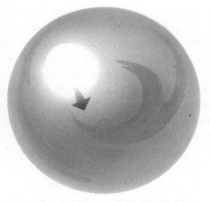

Fig. 8-50. Brush in and soften a white highlight.

Fig. 8-47. Line drawing of a sphere.

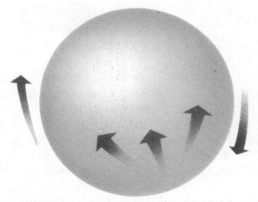

Fig. 8-48. Airbrush the edge of the hard sphere.

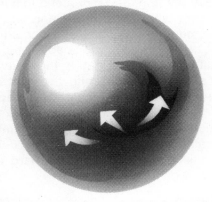

Fig. 8-51. Brush in and soften a small dark crescent.

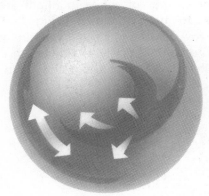

Fig. 8-49. Airbrushed crescent at the bottom of the hard sphere.

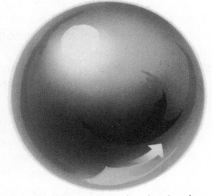

Fig. 8-52. Finished airbrushing of a hard sphere results in the hard appearance of a ball bearing.

over it, making sure the rest of the board is not exposed to airbrush overblow (Fig. 8-47). Carefully cut out the circle either by placing a compass knife in the pencil portion of the compass or by freehand cutting very carefully with a frisket knife. Remove the frisket from the circle and gradually airbrush a #3 gray lightly around the entire edge of the circle in a curved rocking, back-and-forth motion in short smooth strokes (Fig. 8-48). Remember the 1-2-3 motion (see Topic 7). Next, in a curved motion from the bottom right-hand portion of the circle, airbrush upward toward the center, not quite reaching the center. Allow a highlighted circular portion of the sphere near the upper left (Fig. 8-49). Paint in with #3 gray a double crescent shape on the right-hand bottom, ½ inch within the circle and opposite the light source. Also, paint in a narrow stroke on the left-hand side of the circle; soften both with the airbrush. Then, paint in with clean white a circle about one-fifth the size of the sphere, and airbrush the lower portion of the white circle with white paint until it gradually fades into the sphere (Fig. 8-50). To achieve the hard appearance, we will paint in a shorter crescent shape, using black, that falls within the previously painted #3 gray crescent (Fig. 8-51); proceed to soften this black crescent with the airbrush and short gradual strokes, permitting a band of reflected light at the bottom and carrying the tone above the bottom to bring out the reflected light. In the lower reflection area and directly opposite the light source, a small area of brushed-in #2 gray should be painted in and softened with #2 gray in the airbrush, which is blown around the circumference from the painted area to the right (Fig. 8-52). Remove the frisket and you have the hard appearance of a ball bearing.

Cylinder (Hard)

Cylinders are rather simple, since you can follow the same procedure as for the soft handling of the cylinder, with the exception of some extra work, as follows (Fig. 8-53).

To harden the look of a cylinder when the airbrush portion is finished by using the brush and

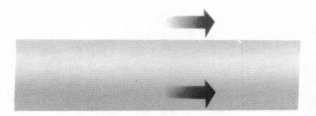

Fig. 8-53. Airbrushed upper section of a hard cylinder.

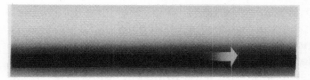

Fig. 8-54. Brush in a dark band on the cylinder and soften.

Fig. 8-55. Brush in a white band on the cylinder and soften.

Fig. 8-56. Finished airbrush of a hard cylinder.

bridge (see Lesson 2), a dark gray or black band is painted in the dark shadow area above the reflection area and parallel to the bottom (Fig. 8-54); then the top of the band (toward the highlight area) is airbrushed with a narrow spray, softening the top of the black band but being careful not to overspray the middle tone area too much. A second step is taken to brighten the highlight. A thin band of pure white is brushed in across the top portion of the soft white highlight area, using the bridge to make it parallel (Fig. 8-55). Then, with a narrow controlled spray of white, the bottom of the white band is softly blended with the background while the top of the white band remains hard (Fig. 8-56).

Topic 9

THE CLEVIS AND TUBE

(Lesson 8)

This lesson will provide you with the opportunity to combine some of the geometric shapes that you practiced earlier. The cylinder and the cube are combined to produce the clevis and tube.

Make a tracing of the line drawing in Fig. 9-1; then transfer it to a good card stock or illustration board. Prepare a frisket for the drawing and remove the portion, as shown in Fig. 9-2. This tubular part will be done like the cylinder exercise, with a source of light at the upper left-hand corner. Use a #2 gray for the general tone of the body of the tube, with the top one-third of the tube for highlight purposes. Airbrush a slight #2 gray, holding tone at the top of the tube and a slight shadow in front of the nearest clevis (Fig. 9-3). Using a #4 gray, blow in the shadow line at the bottom, allowing ¼ inch for reflected light; airbrush the #4 gray from the rear of the tube toward the front, gradually darkening the entire rear of the tube slightly. If you have made acetate masks similar to the "cow," you can place the long gradual curve at a point at the forward edge of the clevis where it meets the tube, permitting the long gradual curve to bend around the body of the tube

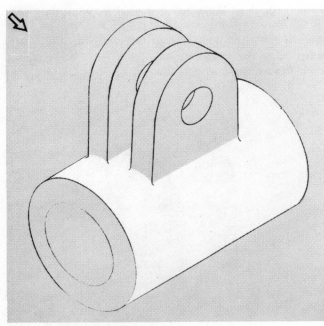

Fig. 9-2. Remove the frisket from the tube section.

toward the far end. By placing a straightedge card at the vertical portion of the clevis, you can blow a #5 gray shadow from the base of the clevis toward the back of the tube, fading as you approach the middle of the tube.

Now remove the frisket from the flat sides of both clevises, leaving the thicknesses frisketed on

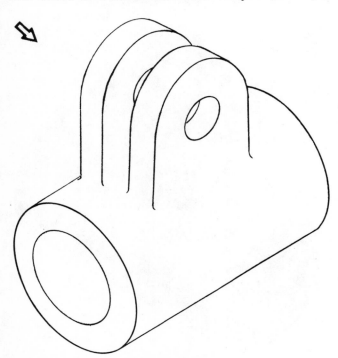

Fig. 9-1. Line drawing of clevis and tube.

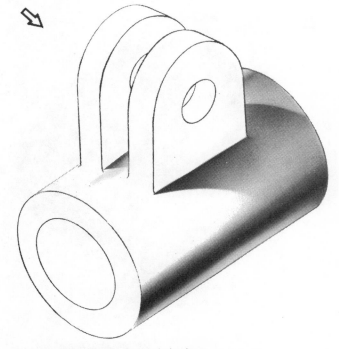

Fig. 9-3. Airbrushed tube and shadows.

both (Fig. 9-4). Airbrush a #2 gray on the clevis sides, moving from the curved top and the far side toward the tube and fading out as you move forward. Use #4 gray and airbrush the dark color from the forward edges toward the back, with real

dark areas at the top of the clevises and at the lower joining edge. Refrisket the clevis sides and remove the frisket from both thicknesses. With #2 gray, blow in the area at the top and back of the thickness areas (Fig. 9-5). Now do the area in front

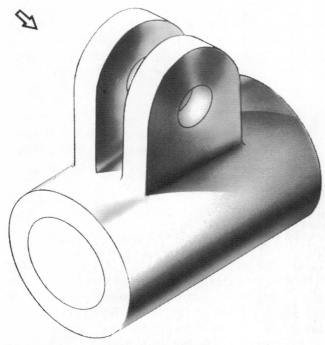

Fig. 9-4. Airbrush the sides of the clevises.

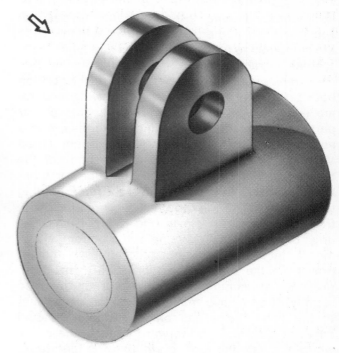

Fig. 9-6. Airbrush the tube end.

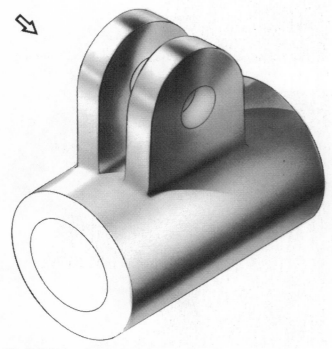

Fig. 9-5. Airbrush the clevis thickness.

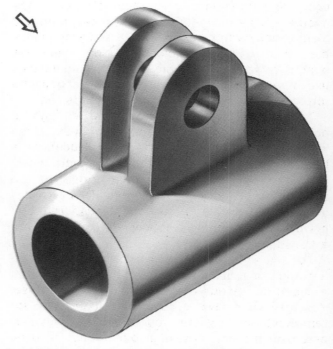

Fig. 9-7. Finished airbrush of the clevis and tube.

of the rounded top down the vertical area that joins the tube. At the actual curve on the thicknesses, airbrush two parallel fine lines, with #4 gray to accentuate the highlight on the curves.

The front end of the tube should be airbrushed with a #2 gray in a flat wash, as shown in Fig. 9-6. The hole in the tube should be either frisketed or a large isometric ellipse guide should be used to airbrush a #5 gray at the upper part of the hole, fading-in a curve as you approach the highlighted lower portion, as shown in Fig. 9-7. The frisket is

then cut to show the thickness of the clevis and the pin holes, and airbrushed in #4 gray dark at the top and fading at the bottom. The two pin holes can be worked with a small ellipse guide or frisketed; then a dark tone of #4 gray is blown over the actual hole area. Remove all friskets and touch up with brushwork as necessary. Have you remembered to protect all areas from overspray? If you have a slight score mark at the base of the clevis in the shadow area, you can remove this with brush and bridge and a matching gray.

Topic 10

OPAQUE AND TRANSPARENT PAINT

It is necessary for the artist to understand the use and relationship of opaque pigments and transparent pigments, whether in black and white or in color, in order to accomplish the desired end result. They may be used alone or in any combination; the manner of combining them will govern the results.

Opaque colors will cover quickly and completely, as in photo retouching or in changing an existing piece of artwork (Fig. 10-1). Naturally, when using opaque paints, you would start with the middle tones and work to the dark tones; then add highlighting. With black and white and gray paints, the name usually indicates whether they are opaque or transparent. Color paints will sometimes use other names for opaques, such as gouache (pronounced *gwash*) or designers colors, etc.

Transparent colors will not cover enough to obliterate an existing subject (Fig. 10-2). When working with transparents, the usual procedure is to start with the darks, blend out to middle tones, and utilize the actual paper or material you are working on to carry the highlights. This provides a clean appearance to the work. Transparent colors usually state on the tube or jar that they are a transparent color.

For example, you may have to remove or change a portion of a black-and-white photograph to suit a client; an opaque color is what you would use. You may then have to color that photograph for reproduction; therefore, you would use transparents over the opaques; or if only a part is to be colored to emphasize it, you would use dyes (very

carefully) which would not dull or obliterate any of the detail. This exercise is covered in section II of this book.

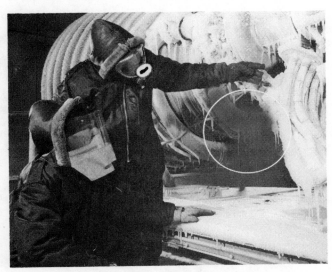

Fig. 10-1. Airbrushing opaques on photographs.

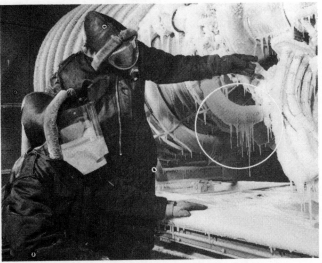

Fig. 10-2. Airbrushing transparents on photographs.

Topic 11

OVERSPRAY AND PREVENTION

As mentioned earlier in using the airbrush, one must be careful of overspray when masking an object, by using either dry masks or frisket (Fig. 11-1). If the entire area around the part being airbrushed is not covered, you will obtain a pattern which is sprayed where you do not want it; and if it goes unnoticed, the sprayed pattern may appear on the reproduced work, which would appear very unattractive. The simplest way to prevent this occurrence is to keep in mind that by merely taping tear sheets of bond or other thin paper around the unfrisketed area, you will have provided the object or pattern with sufficient protection against overspray.

Fig. 11-1. Airbrushed photograph, with overspray (top) and without overspray (bottom).

Topic 12

AIRBRUSHING SPECIAL EFFECTS

With the airbrush as a means and the use of actual materials, a wide variety of effects can be accomplished for realistic or design appearance.

To achieve a coarse or rough appearance, a drybrush technique, plus airbrush overspray, will make a striking effect. With a bristle or other coarse brush, using heavy paint and dragging the tip of the brush across the area where a rough ground effect or a wood effect is desired, and then overspraying in an irregular stroke, a special effect is created.

Another useful combination involves the use of a coarse or fine stipple. Using normal paint consistency and cutting down on the air pressure at the air valve (to 5 or 10 pounds) or pinching the hose between thumb and forefinger, the size of the stipple desired can be controlled.

A spatter can be obtained with the airbrush by thickening the paint in the cup and lowering the air pressure, as mentioned above. This effect, in combination with soft airbrush work, can make a water effect or a coarse metal effect.

The use of window screen or filtering screen material in coarse or fine pattern is effective, when held flatwise against the work and sprayed through with the airbrush. In using this effect, a frisket must be cut for the area to be rendered; the screen material must be held as flat as possible against the background, while the airbrush is held at a 90° angle to the work and without angular movement to the airbrush while spraying from a distance of about two inches from the work.

Airbrushing through cheesecloth is handy for obtaining a coarse appearance. This is handled in the same way as the screen material, keeping in mind that the cheesecloth will move, if not pulled tightly and held in place firmly.

Coarse materials, such as burlap, monk's cloth, etc., give good effects when blown through with color in the airbrush. Torn sheets of different types of paper also are used for special effects, as is spraying across one of your fingers—you can obtain effective spot highlighting by bending an index finger and spraying a few short strokes across the finger at an angle. Any of the aforementioned techniques can be combined in various combinations.

Special Effects
(Lesson 9)

This lesson will provide you the actual experience of preparing a piece of art by utilizing three of the aforementioned techniques. To accomplish this lesson, you will need a piece of flat screen material, the fineness or coarseness of screen is your choice.

Make a tracing of the line drawing in Fig. 12-1; transfer it to a piece of illustration board by blackening the back of the tracing with pencil. Note that we will be using the stipple, dry brush, and screen techniques for making a cement pipe with a wood cap and a filter screen that completely surrounds the pipe.

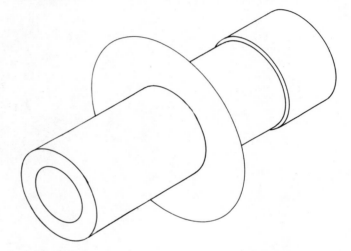

Fig. 12-1. Line drawing for airbrushing special effects on part.

Make a frisket for the entire part; lightly cut the cement pipe portion and remove the frisket (Fig. 12-2). Airbrush a soft #2 gray over the entire pipe section. Then use #4 gray and allowing ¼ to ⅜ inch from the bottom, lightly airbrush a parallel area the entire length of the pipe; also airbrush one or two quick strokes across the top of the cement pipe. Then, using a dry mask or ellipse guide, mask the end of the cement tube and lightly airbrush a #4 gray overspray on the end of the cement pipe. Then using an ellipse guide to make the hole or by cutting a frisket, airbrush the pipe hole with #4 gray, dark at the top and fading at the bottom. Clean the color out of the airbrush and replace with a clean white paint; airbrush across the entire pipe in a stipple, with irregular strokes and the air pressure cut down to allow the stipple (Fig. 12-3). Push down and intermittently forward and back on the front lever con-

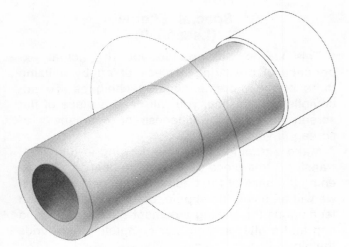

Fig. 12-2. Frisketed cement portion.

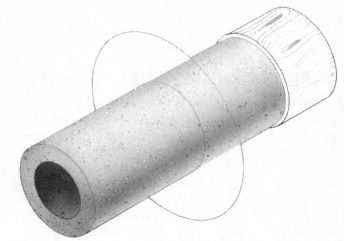

Fig. 12-4. Grain and dry brush on wood cap.

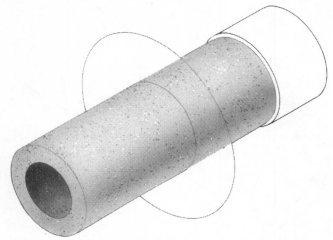

Fig. 12-3. Stippled cement pipe with white and dark tone.

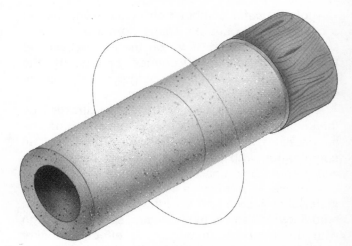

Fig. 12-5. Light overspray from airbrush on wood cap.

trol, causing a stippling effect. Be careful not to let the lever snap forward, since this will injure the tip. Try to vary the size of the stipple by changing the pressure slightly as you airbrush. After you have achieved a coarseness that is pleasing, clean the airbrush again and place a #5 gray in the cup. This time, stipple all the other areas on the cement pipe not previously airbrushed with white stipple. It will take less dark stipple to achieve a pleasing effect; do not overdo, remember that work with frisket around it appears lighter than work with the frisket removed. Now, refrisket the cement pipe and cut out and remove the frisket around the entire cap. Here we will use handbrush technique for the wood effect (Fig. 12-4). Using #3 gray in a fine hand brush with a thin mixture, try the fine brushwork on a sheet of scrap paper first to obtain the feel of the brush before putting it on the final artwork. Then apply a few

long curvy strokes with the brush to simulate a wood grain. Now airbrush a light coverage of #3 gray, without obliterating the wood grain (Fig. 12-5). The end of the cap that provides thickness to the wood should be handled as shadow and done with solid #3 gray at this time. The wood cap should have barely a slight hint of darkness at the bottom. Remove the frisket covering the cement and wood portions of the art. Place a new piece of frisket over the screen portion, and cut and remove the frisket from the part to be screened (Fig. 12-6). By means of tape and weights and by holding down with your free hand, place actual screen material over the area. Remember to hold the airbrush perpendicular to your work and move your entire arm across the area while airbrushing. Do not twist your wrist, since this will underspray the screen and prevent a sharp image of the screening. Use a #5 gray for airbrushing

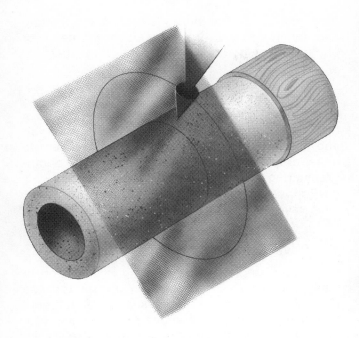

Fig. 12-6. Screen area.

the screen pattern. Remove all remaining frisket and touch up the edges of the job, as necessary (Fig. 12-7). It is difficult to use these techniques and if your first attempt is not totally satisfactory, try it again.

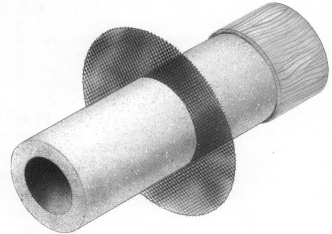

Fig. 12-7. Finished part with special effects.

Topic 13

PHOTO RETOUCHING
(Lesson 10)

Obtain an 8 × 10 glossy photograph of any subject.

Mounting and Cleaning

When you receive a photograph to retouch for a client, it will usually be an 8 × 10 glossy print. He will want the print cleaned up with the airbrush and some detail highlighted and brought out or some detail added or removed. The photograph must be handled carefully to prevent a crack or fold in the emulsion. The best procedure is to mount it as soon as possible. The mounting can be accomplished in two ways: (1) wet mounting and (2) dry mounting.

In wet mounting, a rubber cement is used on the back of the photo *and* on the mounting board, permitting both surfaces to dry and carefully placing the upper edge of the photo on the board—then following through with the rest of the photo-

graph. Make sure there are no warps or creases before rolling the photo firmly in place with a brayer or photo mounting roller. Remove all excess rubber cement from the border of the mount board.

In dry mounting, use dry mounting tissue cut exactly to the size of the photograph and tacked to the back of the photograph with a hot tacking iron. The photo is then centered on the mounting board and this time tacked with the hot iron placed gently on a sheet of paper over the surface of the photo to prevent marring the photographic surface. Then, the board, with the photograph facing up and covered with a clean piece of bond paper, is placed in an electric dry mounting photographic press for 10 seconds; this heat melts the dry mount tissue which consists of sheets of dry shellac, and the photograph is mounted, ready to work on. Cleaning the photo to remove all fingerprints and grease is accomplished with sterile cotton and *Energine,* plain water, or saliva. This might seem unsanitary, but it is an excellent grease remover. Rub gently across the entire surface before beginning the retouching. Keep the surface moist or the cotton will stick to it. If this occurs, use a second piece of cotton, making sure it is quite damp.

Preparation and Frisketing

Determine what work must be done on the photograph, keeping in mind that the furthest portion should be done first to prevent working across a finished area. Use masking tape on the photo border to retain a clean appearance when you are finished with the retouching. Cut the necessary friskets or use dry masks to accomplish the desired effect. Work with a sharp knife and use care in cutting friskets, since a cut mark on the surface of a photographic print might not be removed; you might need to change the photograph at a later date, which may show the cut mark. Use the brush and bridge to enhance the work with highlights and shadow-line work. Do not completely outline a piece of work. Remember that a small amount of cotton at the end of a sharpened brush handle will help in cleanup. The main function of photo retouching is to obtain an improved reproducible original for newspaper, magazine, and advertising literature, which is photographed in halftone to be reproduced by a printing press or in fultone to make additional photographic prints (Fig. 13-1).

Since only a few photographs capture the lighting and details desired for reproduction, the need for photo retouching is always present (Fig. 13-2).

Editorial or Newspaper Retouching

The news photographer normally does not have time to set up a good photograph for the paper, and his prints generally require work on them to either drop back or bring out portions of the photographs (Fig. 13-3). In most instances, there is only one opportunity for a photo, and the retoucher must save it for reproduction.

Advertising or Product Retouching

In advertising, photo retouching is called on to make a photo of a new product appear realistic (Fig. 13-4). Sales literature is usually the first news of a new product, and photographs are taken of a mockup or a handmade product merely to fill the need for a news release of a new item. Usually, there are mold marks or other poorly finished surfaces present on the photograph; these must be

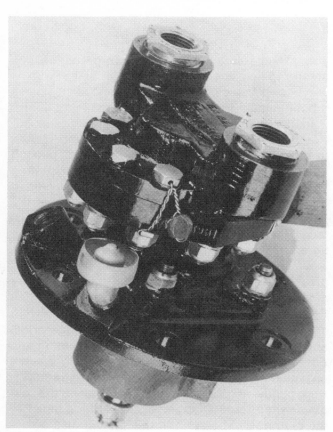

Fig. 13-1. Photograph before retouching.

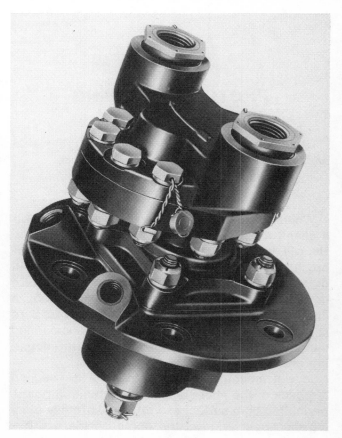

Fig. 13-2. Photograph after retouching.

(A) Before retouching.

(B) After retouching.

Fig. 13-3. Newspaper photo.

(A) Before retouching.

(B) After retouching.

Fig. 13-4. Advertising photo.

smoothed out and cleaned up for reproduction. Photo retouching of a corrective nature is also commonly used in advertising, whereby a photograph might have been taken of a kitchen, with cluttered table or background that had to be removed. The photo retoucher would have to remove the clutter and replace it with suitable background material. In some instances, a brochure cover is required in a horizontal format when only a vertical photograph is available (Fig. 13-5); the procedure here is to print the vertical photo on an oversize horizontal piece of photographic paper and to fill the horizontal format with the type of airbrush background work necessary.

Industrial and Mechanical Retouching

Mechanical retouching could deal with sharpening up a photograph of a handmade part for reproduction or with retouching a piece of equipment or mechanical parts for a catalogue (Fig. 13-6). Photo retouching is used frequently in the instructional field and in model building. A photograph might require removing the background or merely toning down the background in a way that it does not command too much attention when it is reproduced.

Photographs of industrial plants are sometimes required to show the expansion of a factory, be-

(A) Square or vertical format.

(B) Changed to horizontal format.

Fig. 13-5. Brochure cover.

fore it has been built. In this instance, a print is made on an oversize piece of photographic paper, and the retoucher might work from blueprints or sketches to construct and airbrush a realistic view of the new addition to the plant. Industrial photo retouching can be very detailed or merely require

(A) Before retouching.

(B) After retouching.

Fig. 13-6. Industrial photo.

product retouching to enhance a photograph of perhaps a glass or metal object needing separation and highlighting. Industrial requirements may have a need to show the inner workings of a valve or mechanical part; this would require cutting away a section of the part and drawing the controls and channeling within the part; or it might require ghosting the part to show the internal mechanism. There might be a requirement to airbrush a sectional view of an entire plant or factory; therefore, the retouching might be quite different and varied for industry.

Restoring Old or Torn Photographs (Lesson 11)

You might be called upon to restore an old portrait that has been handled poorly or one that might have deteriorated and partially fallen apart (Fig. 13-7). This procedure would require recopying the original and doing the repair work on a new print. The step-by-step procedure of repairing an old portrait is shown in Figs. 13-8 and 13-9. First, the background is matched; try to retain the vintage look by using coarse sprays and perhaps

some stippling (see Fig. 13-8). Second, the figures themselves are worked on (see Fig. 13-9). It is important to retain the original feel in retouching; be careful not to make the figures appear ghostly or powdery; and build up the airbrush work gradually, extending any patterns or graininess in the original. Always work with a sheet of paper under your hand to protect the work already done.

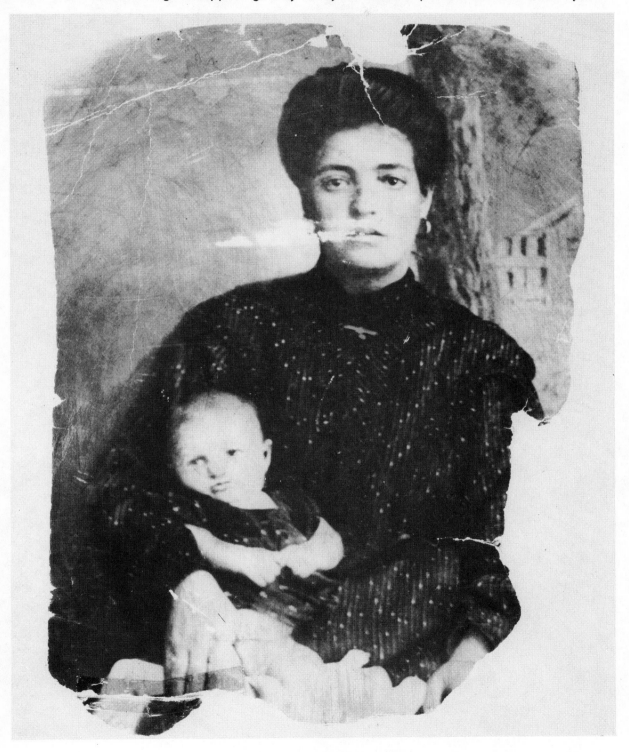

Fig. 13-7. Old portrait—unretouched.

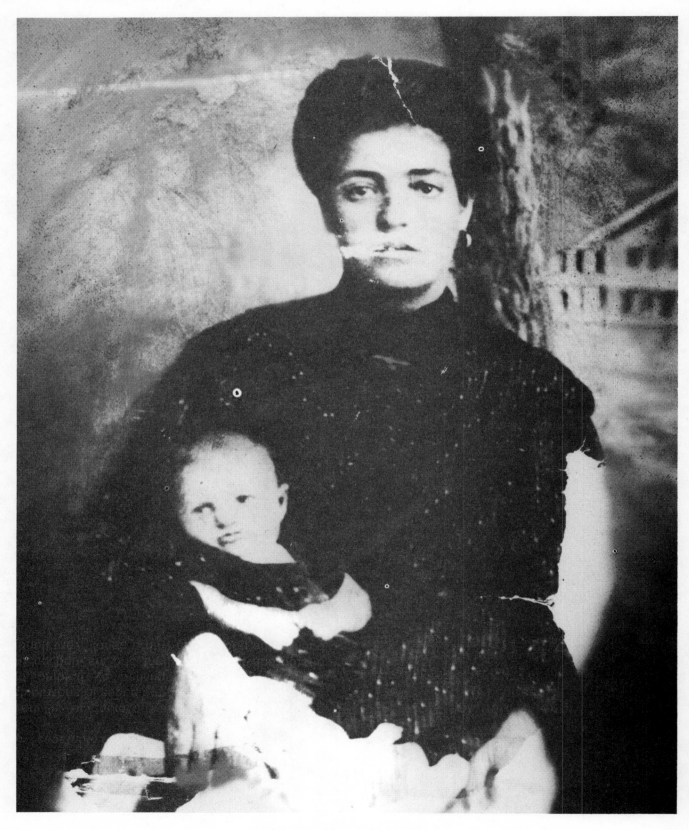

Fig. 13-8. Background retouched.

Fig. 13-9. Subject retouched.

Topic 14

AIRBRUSH WORK ON ACETATE OVERLAYS

(Lesson 12)

For various reasons, you may be required to work on an acetate overlay. The acetate must be clean and fingerprint-free at all times; handle the sheet by the edges only, taping it at the top (Fig. 14-1). You may not successfully clean an acetate overlay, since it will tend to smear; the actual wipe off may show clearly once you have airbrushed

Fig. 14-1. Washed-off cel. Note overspray and cut marks.

Fig. 14-2. Airbrush on cel over art or photo.

color over the area. Cutting friskets or the use of dry masks over the acetate must be done with extreme care, since the score line from the frisket cutting will tend to show. Some reasons for working on an acetate overlay would be: (1) The client might want to show the original photo and an addition to that photo for comparison (Fig. 14-2); (2) Only one photograph might be available, which the client would like to retain with and without changes; (3) The photograph might have a tear or crack which could not be taken out successfully by working directly on the photo (Fig. 14-3); and (4) Ball-point pen marks cannot be removed— these marks will continuously fade back into the photo, even through an unusually heavy airbrush covering.

Place a clean acetate overlay over the retouching you completed in Topic 13 (Photo Retouching). Then tape the top of the sheet to the top of the retouching with a single strip of masking tape, being careful not to touch the surface. Proceed to frisket out a specific area on the acetate overlay and airbrush with matching grays to remove that predetermined part from the retouching. All airbrushed photographs must be protected with a cover flap; brown craft paper or bond paper are excellent for this purpose. Do not use vellum or tracing paper for this purpose, since they contain oil which will transfer to the airbrushed surface and cause a stained mottled appearance. Work

Fig. 14-3. Torn or cracked photograph for retouching.

done on acetate overlay is especially susceptible to scratching and chipping; protect the surface well.

Topic 15

PHOTO MONTAGES

Two types of photo montage are generally called for. The rectangular or regular type is composed of a number of varied-size rectangular photo prints placed together to form a large photo montage. They tell the story of many pieces, all of which are equal to one photo. The second type of photo montage also is made up of a number of smaller photographs; but they are prepared in an irregular manner, vignetting into each other with no hard separation between photographs. These photographs are prepared in a way that they blend into each other, making a single photograph with many subjects.

Regular Montage
(Lesson 13)

Obtain a number of small prints; the subject matter is not important in this exercise. To prepare the regular rectangular montage, trim out sections of the photographs in a variety of interlocking shapes, squares, rectangles, or other shapes (Fig. 15-1); be careful to prepare these cutouts in a manner that they can be placed together without white background showing between them. When you have placed them together to form a single montage, mark their positions on a sheet of tracing paper; then you can replace them in the same manner again. Each cutout print then must be edge painted (Fig. 15-2). Use the gray tone that more nearly approximates the tone on that

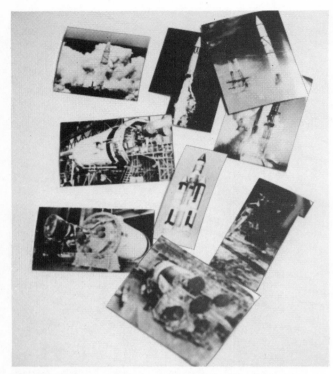

Fig. 15-1. Regular montage—with photographs cut out.

Fig. 15-2. Regular montage—edge painted.

photo and paint the edge by drawing the paint-filled brush across the edge, with the photograph facing up. This will deposit the excess paint on the back of the photo, rather than on its front. When this is done, apply rubber cement to the back of each individual photo and also to a mount board (white) large enough to allow a 1-inch border around the edge. When the rubber cement is dry,

use the tracing paper outline you have prepared and place the small photographs in the corresponding positions. Now, clear off all the rubber cement from the edges of the photographs and touch up any white spaces that may remain between the mounted photographs. Roll the photographs down firmly with the brayer or the mounting roller (Fig. 15-3).

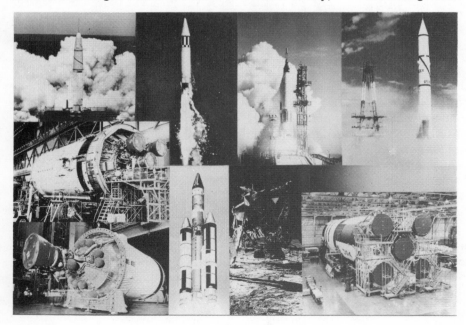

Fig. 15-3. Regular montage—finished.

Vignette Montage (Lesson 14)

Preparing the vignette montage is a little more difficult, since there are no hard edges to the individual photographs. Each of the smaller photo-

graphs that will make up the montage will have to be torn carefully along the edges in an irregular fashion. This is accomplished by holding the photograph toward the light and marking on the back of the photograph with a pencil, very lightly,

Fig. 15-4. Irregular montage—tearing photographs.

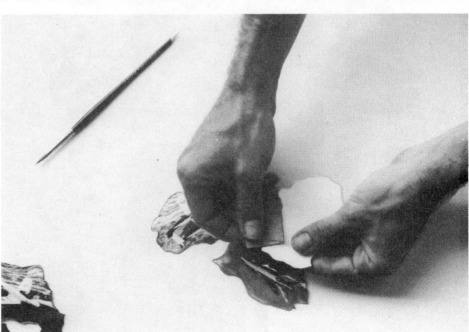

Fig. 15-5. Irregular montage—sanding backs of photographs.

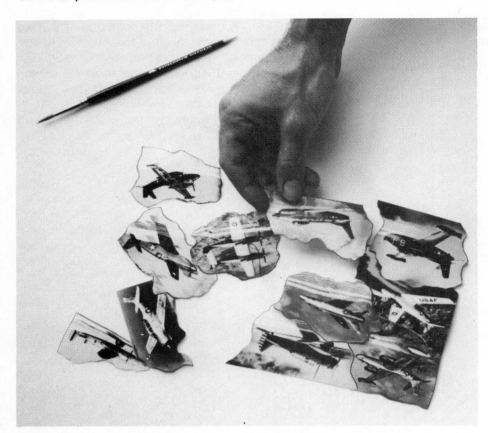

Fig. 15-6. Irregular montage—over-lapping photographs.

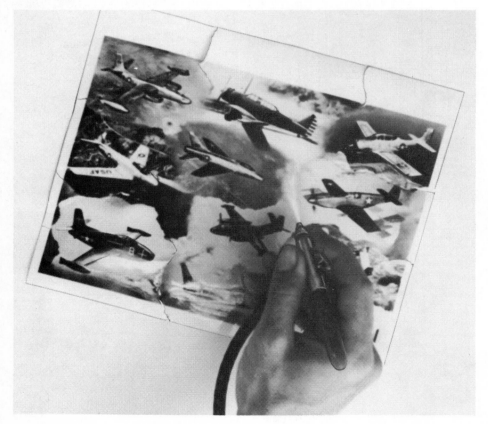

Fig. 15-7. Irregular montage—re-touched photographs.

the area that you must tear around; then lay the photograph face down on your drawing table and proceed to tear off the unwanted portion (Fig. 15-4).Tear in a flat manner toward the part you want to use; this will remove a portion of the photograph paper from behind the photograph, making an irregular edge. Then, with a fine sandpaper, sand the edge of the torn photograph with single strokes away from the center of the picture, being careful not to catch the edge and fold it over (Fig. 15-5). When all the photographs that you want to use in the montage are completed, lay them in the positions you wish; make a tracing-paper layout and rubber cement both the backs of the photographs and a white mount board large enough to allow a 1-inch border. When the rubber cement is dry, place the smaller photographs on the mount

board, one at a time, using the tracing-paper layout for a guide (Fig. 15-6). You will have to apply a small amount of rubber cement to the overlap area of each of the photographs as you mount them. Note that there is no edge painting here. When all the smaller photographs are mounted in place, roll the montage down firmly with the brayer and remove all excess rubber cement by rubbing the rubber cement pickup eraser from the center of each photograph toward the edge, making sure not to lift any edges. Now the airbrush is brought into play. Softly airbrush the overlap edges with the corresponding tones of gray to blend the torn photograph edges (Fig. 15-7); do not try to obliterate the edges, merely soften them to lessen the overlap edges. Note the finished irregular montage (Fig. 15-8).

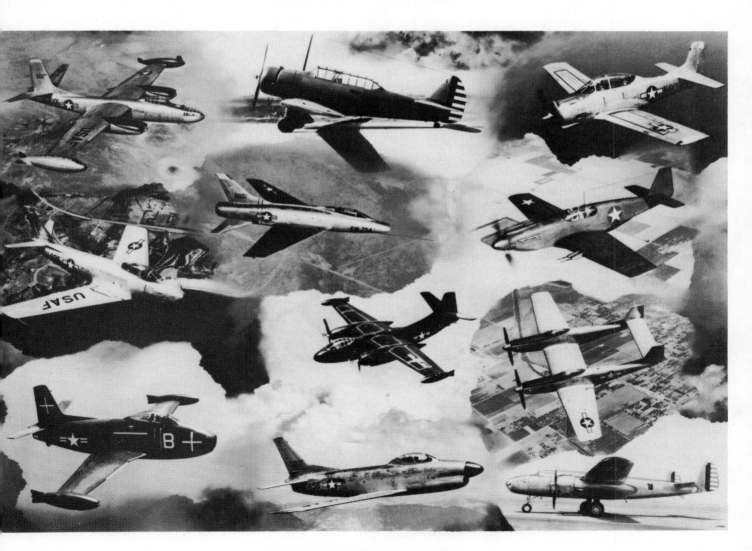

Fig. 15-8. Finished irregular montage.

Topic 16

AIRBRUSH AND THE HALFTONE PHOTOGRAPH
(Lesson 15)

You may be asked to retouch a halftone photoprint for recopying. This is extremely difficult, since you cannot remove all the screen pattern and that portion with screen dots will recopy for reproduction with a moiré pattern. A moiré will show up as a diamond pattern on the reprinted photograph (Fig. 16-1). If you ever are required to work on a screened print, make some agreement with the client that if a moiré shows, it is beyond your control. It may be a rare occasion that you will be called on to do this work but, nevertheless, this might occur. A little airbrush work will diffuse the halftone dots enough to recopy, but the difficulty lies in the fact that to evade the moiré pattern, the entire print must be worked over (Fig. 16-2). Try to remove halftone dots by taking a printed photograph from a magazine and after mounting the printed photograph onto a firm piece of board, airbrush in the same manner you would airbrush for an actual photograph. Remember that you need only to soften the dots; they do not have to be removed entirely.

Fig. 16-1. Photograph with halftone dots.

Fig. 16-2. Photograph with halftone dots airbrushed out.

Topic 17

COMBINATION EFFECTS

Various combinations of line and photograph can be achieved for effective presentations. In presenting a complete picture, perhaps only the photograph of the part is available, but the area surrounding that part is not available photographically; then a line drawing of the surrounding background can be made. By placing the retouched part directly on the line drawing in its correct position, one halftone copy of the entire piece is made for reproduction. The result is a retouched part in full grays with a screened line and background (Fig. 17-1). Another effect with the same art can be accomplished by placing the retouched photograph on an overlay with the line drawing

background below it, making a line copy of the drawing and a halftone copy of the retouching, and combining the two for a line and screen combination. The result will be a halftone retouched photograph on a plain line background (Fig. 17-2). Both these effects can be reversed, creating two additional effects by handling in a like fashion, with the exception being that the backgrounds are available and not a photograph of the part. You would then obtain either a screen line part on a screened retouched background (Fig. 17-3), or a plain line part on a screened retouched background (Fig. 17-4).

Note: The halftone screen referred to can be seen on any reproduced piece of art or photograph by examining with a magnifying glass. Any art or photograph must undergo this process to be reproduced by a printing press for a magazine or newspaper.

Fig. 17-1. Retouched part with screened line background.

Fig. 17-3. Retouched background with screened line part.

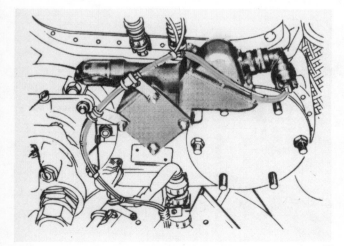

Fig. 17-2. Retouched part with line background.

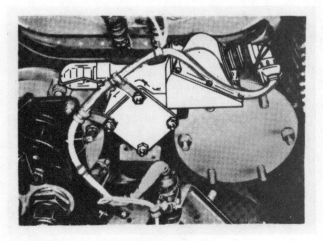

Fig. 17-4. Retouched background with line part.

Topic 18

GENERAL AIRBRUSH APPLICATIONS

Airbrush work can be separated into three general categories — airbrush rendering, airbrush photo retouching, and airbrush production. With this in mind—much like commercial art or technical art—there are many categories that make up a particular phase of art; within these categories, there are various operations.

Airbrush Renderings

Airbrush renderings are classified in the following applications.

Advertising Illustrations and Posters

Complete airbrush art or, more effectively, a combination of brush and airbrush (Fig. 18-1) is used to create realistic (Fig. 18-2), stylization, or mod handling.

Fig. 18-1. Combination airbrush and brushwork for advertising illustrations.

Fig. 18-2. Airbrush rendering for a poster work.

Fig. 18-3. Airbrush rendering for an external part.

Industrial and Mechanical Renderings

Illustrations of industrial plants, machinery, or parts can be done with the airbrush to convey a pictorial, illustrative, or an operational function. External (Fig. 18-3), ghosted (Fig. 18-4), or cutaway (Fig. 18-5) techniques in either black and white or color can be done effectively.

Fig. 18-4. Airbrush ghosted art.

Fig. 18-5. Airbrush cutaway.

Fig. 18-6. Airbrush medical illustration.

Medical Illustrations

This highly lucrative field is now turning more and more to the use of the airbrush to show various internal systems within the body, since this can be accomplished in a very dimensional manner (Fig. 18-6). Coupled with artistic training, one also must understand the medical anatomy.

Motion Picture Animation

This field actually depends on the airbrush and its effects for producing animated cartoons for the public and private industry, training films for industry and the military, educational instruction films, and various other areas (Figs. 18-7 and 18-8).

Fig. 18-7. Motion picture animation cartoon.

Fig. 18-8. Motion picture training animation.

Designs

Fine tonal and color designs for paper products, stationery, wrapping paper, textile designs to be reproduced and generally any area where a graded tone effect is desired (Fig. 18-9).

Fig. 18-9. Textile/paper product design.

Portraiture

Gradual shading for fine tonal effects to prepare likenesses of motion picture people for posters, displays, and for advertising purposes (Fig. 18-10).

(A) Before.

(B) After.

Fig. 18-10. Changing faces in portraiture.

Special Effects

Combining the effectiveness of the airbrush with signs or specialized words to portray an effect, such as in the words laser, ice, neon, etc. These may be only a part of a larger poster, but the effectiveness is evident (Fig. 18-11).

Fig. 18-11. Special airbrush effect in lettering.

Product Rendering

New products rarely are available for inclusion in a brochure or flyer. Usually, only a blueprint or an engineering sketch is available. The airbrush is used to make a three-dimensional picture of the part for publication (Fig. 18-12). The artist usually works in close coordination with the design engineer on these renderings.

Fig. 18-12. Airbrush product rendering.

Technical Illustration

Airbrush cutaways of valves and components are used extensively throughout industry for man-uals, instructional films, training programs, and research (Fig. 18-13). Here is a category that has roots in both commercial and industrial fields.

Fig. 18-13. Airbrush cutaways of mechanical illustrations.

Displays and Murals

The initial layouts of the display design for the client, and many times the display itself, are rendered in airbrush. Murals, part of a display, or a commercial venture are rendered effectively in airbrush (Fig. 18-14).

Fig. 18-14. Display and mural renderings.

Photo Retouchings

Photo retouchings are classified in the following applications. Advertising, newspaper photo, and mechanical retouching are discussed here.

Advertising and Product Retouching

Any product on the market ranging from a box of cereal to airplanes can be photographed and retouched for use in an advertising campaign or brochure (Fig. 18-15).

Fig. 18-15. Advertising and product retouching. Before airbrushing (left) and after airbrushing (right).

Newspaper and Editorial Retouching

Any retouching of photographs for reproduction in a magazine, newspaper, or book falls in this category. A photo before and after retouching is shown in Fig. 18-16.

Fig. 18-16. Newspaper photo retouching. Before retouching (left) and after retouching (right).

Industrial and Mechanical Retouching

Airbrush retouching of a photograph of a machine, part, or factory complex, internal or external, for a catalogue or manual can be termed mechanical retouching (Fig. 18-17).

Fig. 18-17. Industrial mechanical retouching.

Restoration of Old Photographs

Restoring old, cracked, or deteriorated portraits is a specialized operation which can be done for the photographer himself or other client (see Figs. 13-7 through 13-9). This involves recopying the poor photograph and working on the new photoprint.

Airbrush Production Work

Airbrush production work is a commercial use of the airbrush by a person not necessarily an artist. The work is done directly on the salable object, using paint other than watercolor and generally using a production single-action airbrush.

Some of the vocational opportunities for airbrush use follow.

Cake and Ice Cream Decorating

Decorations using food dyes, special occasion cakes, and ice cream setups are colorfully rendered in this fashion (Fig. 18-18).

Fig. 18-18. Cake and ice cream decorating.

Textiles

Many textiles are sprayed directly with permanent dyes to utilize the tone gradations and various color overlays (Fig. 18-19). Hand-painted neckties, blouses, shirts, skirts, and scarfs are done in this way.

Fig. 18-19. Textile design.

Toys

Dolls, trains, masks, rattles, etc., are sprayed, using lacquers, enamels, and dyes.

Ceramics

Many glazes are sprayed onto pottery and statuary to obtain blended effects (Fig. 18-20).

Fig. 18-20. Glazes on ceramics.

Plastics

Sporting equipment, novelties, and many other household items are decorated with the airbrush and lacquers or dyes. Colorful renderings on plastics can be achieved with the airbrush.

Section II

Color Airbrush Work

This section deals with airbrush work, using various color media and techniques. We will cover the preparation of the color palette, color usage, color rendering techniques, color photo retouching, preparation of false color process overlays, and an introduction to airbrush work on *cels* for motion picture animation. All these techniques are involved in successful airbrush work.

Topic 19

THE COLOR PALETTE

Prepare the color palette for opaque designers color, transparent watercolor, and water soluble dyes (Fig. 19-1).

Opaque Designers Colors (Gouache)

A 24-color palette using the most generally accepted color combinations which will separate well in reproduction can be prepared in the following manner—FIRST, obtain a plastic egg holder for a dozen eggs; this will provide 24 circular receptacles in which to mix your working colors. If the egg trays are not available, try to obtain a plastic ice tray with round receptacles; if your mixing palette has sharp, square corners, it will be more difficult to work with, since the paint will remain in the corners.

Again, it is important to use a dry color palette for the airbrush. Your experience in working section I of this book will prove the truth of the dry palette in controlling the paint mixture for the best color control. This color palette will be planned by using Windsor/Newton opaque designers colors; other good tube colors available are *Grumbacher Designers Gouache, Pelikan Concentrated Designers Colors, Julian Bassette Designers Colors, Talens Designers Colors,* and others which have corresponding matching colors. Rough up the surface of the receptacles in the tray with sandpaper or a knife to permit the paint to grip the container.

The following *Windsor/Newton Designers Colors* and a good white color, such as Miller's Brush White or Permo White, are necessary. All the colors listed are straight from the tube, except as noted.

1. Burnt sienna
2. Burnt sienna (1/10) with white mixture (9/10)
3. Burnt sienna (1/5) with white (4/5) and a touch of Yellow ochre
4. Burnt umber
5. Flame red
6. Prussian blue
7. Prussian blue (1/10) with white mixture (9/10)
8. Red ochre
9. Ultramarine
10. Yellow ochre
11. Azure blue
12. Azure blue (1/10) with white mixture (9/10)

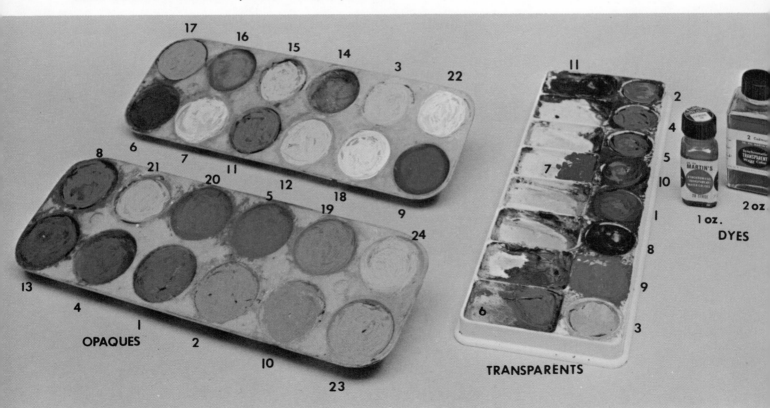

Fig. 19-1. Designers' color palette, with watercolors and dyes.

13. Havannah lake
14. Olive green
15. Permanent green light
16. Permanent green deep
17. Cerulean blue
18. Cerulean blue (1/10) with white mixture (9/10)
19. Cadmium orange
20. Cadmium red pale
21. Cadmium red pale (1/10) with white mixture (9/10)
22. Cadmium yellow pale
23. Cadmium yellow deep
24. Lemon yellow

Note: Fill the wells approximately half full.

Transparent Watercolors

Using a plastic palette that has both wells and flat mixing areas will serve the purpose in preparing a transparent color palette. Again, we will prepare the palette for dry color use by filling the wells half full, directly from the tube. The colors are *Windsor/Newton Artists Professional Water Colors,* as follows:

1. Alizarin crimson
2. Prussian blue
3. Cadmium yellow
4. Permanent blue
5. Hooker's green dark
6. Burnt sienna
7. Windsor blue
8. Sepia
9. Cadmium red
10. Payne's gray
11. Ivory black

The flat areas on the palette can be used for mixing two transparent colors together to form a blend.

Watercolor Dyes

Watercolor dyes or transparents, as they are sometimes called, are usually in liquid form in bottles; these are concentrated color and should be used directly out of the container in the following manner. A brush is dipped into the dye and one or two brushfuls placed into the airbrush cup; dilute the dyes with a similar amount of clear water and they are ready to use. The dyes most commonly called for are *Dr. P. H. Martins Transparent Water Colors;* following is a list of the dye colors:

1. Cadmium orange
2. Cerulean blue
3. Lemon yellow
4. Nile green
5. Payne's gray
6. Scarlet
7. Van Dyke brown

Kodak Company manufactures a watercolor dye in dry form that can be lifted with a wet brush and placed into the airbrush color cup; then, by diluting the color with water, a clear transparent dye is ready for use. These dyes come in booklet form and are called *Kodak Transparent Water Color Stamps,* available from the Kodak dealer.

Color Mixing

Color mixing and matching are extremely important when making changes, adding to or removing something from a rendering or color photograph. You may have occasion to work on an acetate overlay which adds density to the color beneath the overlay. This means matching the color seen through the overlay, which would take a spot of Yellow ochre and perhaps a speck of black to deepen your original color.

When matching color, try to start your basic color in the middle tone of the color you see, then add either to the whitish side or to the color side. An exception to the foregoing rule is—if the basic color is deep and dark; then, of course, you must start with the full color in your mixture. Sometimes, only a speck of another color will add the tonal value needed to make the difference.

When working with the blues, a speck of yellow will green it slightly, while a speck of white will lighten it slightly and a speck of black will darken it slightly. Do not add large amounts of color to change your tone or value, because you will soon find you have wasted a great deal of paint. Mix enough paint for the entire job, plus an excess which you should keep, since the photograph might be sent back for additional work.

When working with the reds, a speck of yellow will orange it slightly and a speck of blue will violet it slightly.

In working with the yellows, a speck of red will orange it slightly and a speck of blue will green it slightly.

All colored surfaces will reflect other colors; it is, therefore, very effective to add a slight complementary reflection at one side of a colored object that you are rendering or retouching.

Keep in mind that all colors basically are combinations of the primary red, yellow, and blues—with whites, blacks, or their complementary colors added in varied amounts.

Topic 20

REFLECTED COLOR—THE SPHERE, CONE, AND CYLINDER
(Lesson 16)

The technique of airbrushing the sphere, cone, and cylinder remains basically the same as when you rendered them in black and white earlier in the book, with some exceptions (Fig. 20-1).

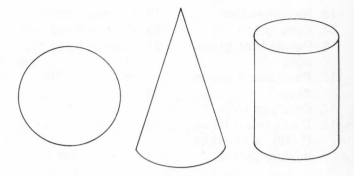

Fig. 20-1. Line drawings of sphere, cone, and cylinder.

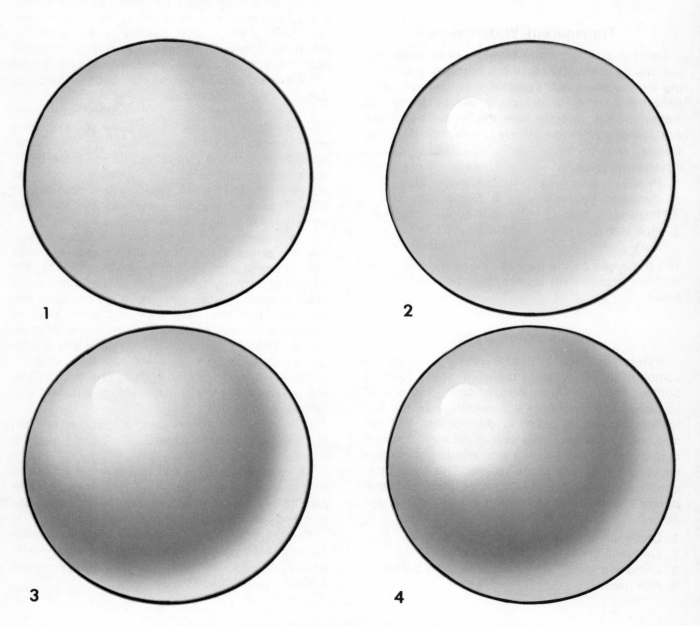

Fig. 20-2. Airbrushing a sphere (Steps 1-4) in color, with reflected lighting.

Color Sphere

The preparation for this lesson is identical to your earlier black-and-white lesson (see Topic 8, Lesson 6). Make a tracing of the shapes and transfer them all to the illustration board. All three shapes can be done on one board. Maintaining a single light source in the upper left-hand corner, you must then decide the color you wish to use. We will use blue in this lesson (Fig. 20-2). Using the mixture of Prussian blue and white from your palette, airbrush the tone completely around the perimeter, allowing a ¼-inch clear area at the bottom of the sphere (Step 1). Next, airbrush the color from the lower side of the sphere in a curved pattern, two-thirds the distance up and toward the light source, allowing approximately one-fourth of the sphere as highlight area. With clean white paint, hand brush in a highlight ball of white in the upper left-hand area of the sphere; then with clean white in the airbrush, haze out the lower portion of the white highlight spot, leaving the hard edge at the upper left-hand area of the white highlight (Step 2). Clean the airbrush and with straight Prussian

blue in the airbrush, blow a crescent of dark color, starting about ¼-inch up from the bottom of the sphere to allow a reflected-light area (Step 3). The reflected-light area at the bottom of the sphere will be airbrushed softly with Cadmium yellow pale from your palette. Airbrush your color from the very bottom of the sphere, about one-fourth the distance around (Step 4). The effect of reflected color could vary the final appearance of the object greatly, depending on the background. Remove all the frisket paper, and note the final appearance of the sphere.

Color Cone

Again, the masking of the cone is identical to that done earlier in the black-and-white section (Fig. 20-3). Using the same blue, Prussian blue with the white mixture, airbrush the left-hand side of the cone with a narrow band of light blue (Step 1) right at the edge of the cone; while on the right-hand side of the cone, a flared-at-the-bottom band is airbrushed from the point of the cone downward to a broadened area at the bottom (Step 2). Allow a tapered area ranging from ¼ inch at the bottom

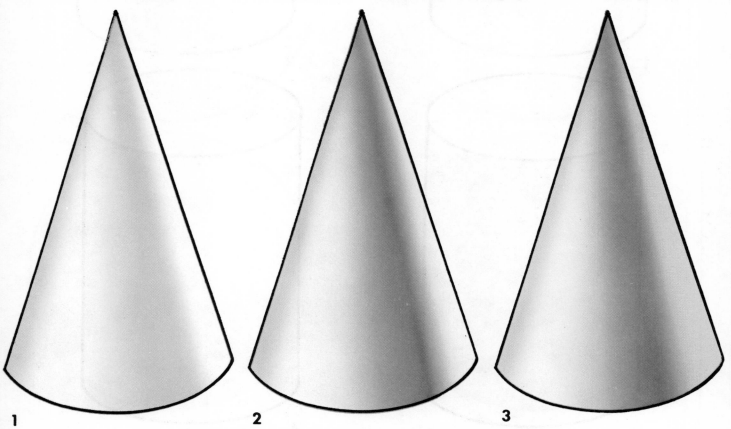

1 2 3

Fig. 20-3. Airbrushing a cone (Steps 1-3) in color, with reflected lighting.

to a diminishing area at the point to remain clear for the reflected-light area. Airbrush the Prussian blue dark color in your palette, from the point at the top, in a slightly expanding narrow band about

¼ inch inward from the right-hand side as you reach the base; this effect rounds the cove. The reflected-light area now can be airbrushed with the Cadmium yellow pale from your palette, giving

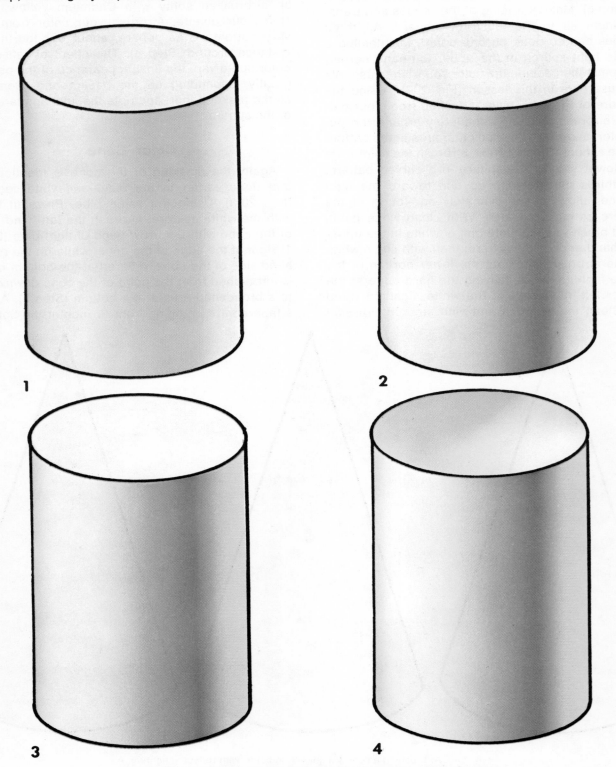

Fig. 20-4. Airbrushing a cylinder (Steps 1-4) in color, with reflected lighting.

the cone a backlighted yellowish reflection (Step 3). Remove the frisket; all your colors should be broad at the bottom and taper toward the top of the cone in a gradual sweep.

Color Cylinder

Mask the cylinder shape, keeping in mind the upper left-hand light source (Fig. 20-4). Use the same Prussian blue and white mixture for airbrushing the middle tone on the cylinder (Step 1). Airbrush the left-hand side of the cylinder in a narrow band along the edge, also applying color to a wider vertical band two-thirds the distance around the cylinder toward the right-hand side (Step 2). Allow a ¼-inch band on the far right-hand side for

the backlighting reflection. Next, clean the airbrush and apply the Prussian dark blue in a narrow soft vertical band on the wide light blue, almost at the point where the yellow backlight will start; then use Cadmium yellow pale and airbrush the far right-hand vertical area, overblowing the middle blue very slightly (Step 3). Remove the frisket and apply a new frisket to the top of the cylinder. Cut the top ellipse and remove the frisket paper. Use the Prussian blue and white mixture to airbrush the portion nearest the upper left-hand light source in a curved pattern, permitting a part of the top to remain very light at the area where the top joins the rendered side of the cylinder (Step 4). Remove all friskets and do all necessary cleanup.

Topic 21

USE OF STENCILS— MOD AIRBRUSH APPROACH

Fig. 21-2. Airbrush art with a mod approach.

Fig. 21-1. Stencils for a poster or advertisement.

The use of stencils in preparing bold posters or advertisements has been somewhat limited in recent years (Fig. 21-1). An excellent example of this

practice is the Wrigley chewing gum ads for doublemint gum, showing two faces or two figures performing in a sports event. You will note that there is a sharp-edge side and a soft airbrush fade on the opposite side, against a white or light-colored background, giving a bold stark effect. There is little doubt of the identity of the product in this type of handling.

The "mod" airbrush approach has gained in popularity in recent years (Fig. 21-2). This effect gives a soft overall appearance to the subject, regardless of the makeup of the material. In normal handling, a realistic appearance is strived for, while the "mod look" gives everything a "balloony look," with lots of billowy shapes with soft airbrushed colors. Television commercials use this type of art, as do magazine illustrations, Sunday supplements, and a number of commercial advertisements.

Topic 22

AIRBRUSH ON TEXTURED SURFACES
(Lesson 17)

In many instances, a strong textured background effect is desired, perhaps as a cover design or for an illustration (Fig. 22-1). To arrive at an effect of this type, you may obtain a textured surface of cover stock of which there are many—simulated-leather stock, linen pattern stock, pebbled stock, and grained stock to name a few; or you can wrinkle a piece of plain paper for an interesting effect. A section or shape may be masked out by using frisket paper. Then, by using a deeper color, a complementary color, or a white paint (depending on the color of stock you use), you can airbrush across the surface of the paper at an angle that is parallel to, and as close as possible to, the paper. This angle of airbrush work will enhance the pattern in the stock and will reproduce as though a directional colored light were shining on the paper.

Another method of texturing for effect is to make a palette knife or heavy brush pattern by using *gesso* or an inexpensive plaster, applying the material to illustration board with a straight palette knife stroke or a well worked out designed pattern. Then in the manner outlined previously, use one or two colors and airbrush a highlight or lowlight across the textured surface to lift the edges out of the background, making it unnecessary for controlled photographic sidelighting which is, at best, a hit-or-miss method of obtaining this effect.

Fig. 22-1. Airbrushing on a textured surface.

Topic 23

SOFT, HARD, AND COMBINATION EFFECTS—COLORS AND HANDLING

When trying to create a realistic appearance of objects, one must look at the object closely to determine whether the reflections are soft, hard, or a combination of both (Fig 23-1). For example, polished aluminum and brushed aluminum are the same metal; but the finish is different and, therefore, they must be handled differently—the polished aluminum has a semihard surface which is accomplished by hand brushing highlights and lowlights onto the finished art and softening the hard line sufficiently to give the impression of the correct finish. The brushed aluminum is a completely soft appearing material and is handled by the airbrush alone, without hard handling. Basic aluminum coloring will be a #2 gray with a small amount of Payne's gray and a reflected color dependent on the background or the other objects nearby. Crystal or glass objects would have hard reflections of a contrasty nature. Some rounded glass corners might be softened slightly with the airbrush. Coloring of glass objects would be in blacks, white, and grays, with color reflected again, depending on the background. Plaster would have a soft opalescent look, while concrete would have a coarse, grainy look, with basic gray colors and reflections, depending on nearby objects or lighting. Wood, whether polished or rough, would have a soft effect—with the polished wood reflecting other color and the rough wood not reflecting other colors at all. Wood colors are quite dependent on the type of wood—dark woods, light woods, and driftwoods. Dark woods would be Van Dyke brown or Burnt umber with a slight Yellow ochre cast or bluish cast. Light woods would be Burnt sienna with white mixture and Yellow ochre or grays. Driftwoods would be basic grays, usually with a bluish cast. Both chrome and nickel objects would be handled with hard reflections accomplished by hand brush with slight airbrush softening in some areas only. The chrome colors are strong blue-blacks with contrasty highlighting of white and also strong reflections of colors determined by nearby objects, while nickel would be warm-toned blacks and all of the reflections would be influenced by the warm tones.

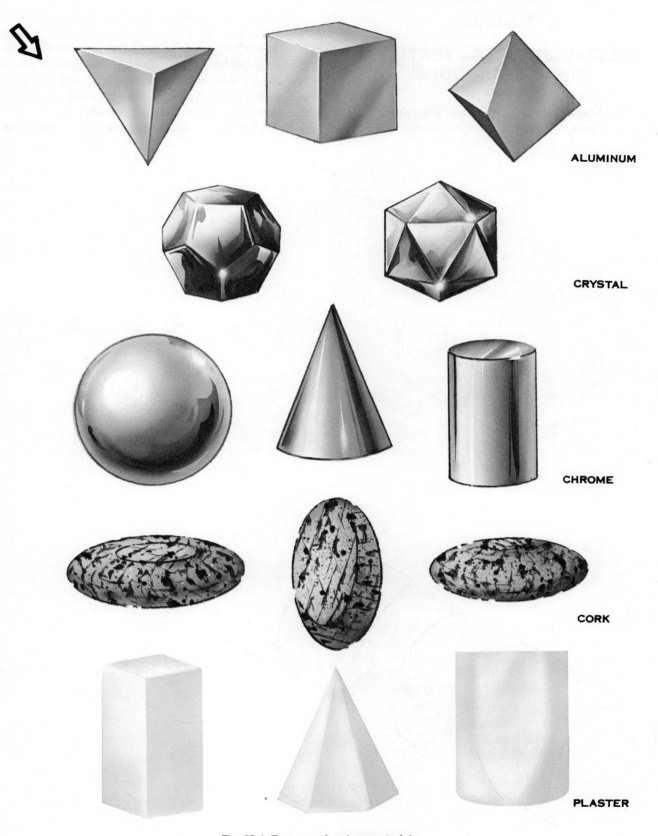

ALUMINUM

CRYSTAL

CHROME

CORK

PLASTER

Fig. 23-1. Textures of various materials.

Topic 24

SPECIAL EFFECTS—TEXTURES AND TECHNIQUES
(Lesson 18)

In the black-and-white section, you were introduced to special effects using screens, stipples, and dry-brush effects (see Topic 12, Lesson 9). Now, we will take the same basic line drawing (see Fig. 12-1), and render it in full color; this time the tube will be chrome, the cap will be red plastic, and the screen will be brass (Fig. 24-1). To begin, you can make a tracing of the line drawing or use the same tracing as before; transfer the image to a piece of illustration board or strathmore paper

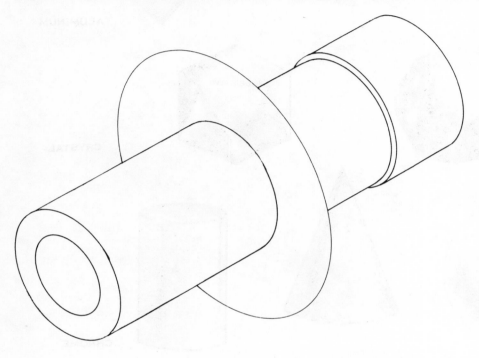

Fig. 24-1. Line drawing of part for special-effects technique.

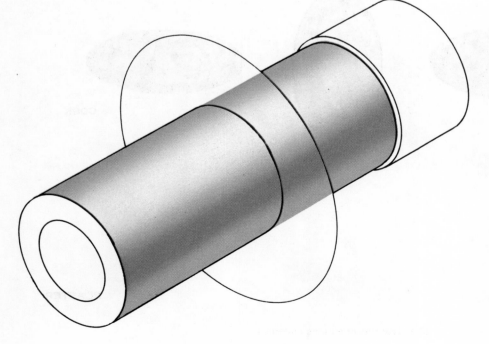

Fig. 24-2. Airbrush on the chrome tube.

which you can then mount on a board for additional firmness.

Note: Be sure to protect the background from overblow in all phases of work.

Make a frisket mask for the chrome tube (remember, upper left-hand light source). Cut out the frisket carefully and remove the frisket covering the tube portion. Now mix a portion of paint (from your dry-color palette), four brushfuls of #1 gray to a half brushful of Payne's gray; the resulting color is a silvery gray. This color is airbrushed across the top of the tube in a ½-inch area and also at the bottom of the tube, being strongest at the area 2 inches from the bottom and fading out above the 2-inch area and softening as you approach at the bottom of the tube (Fig. 24-2). Using Payne's gray

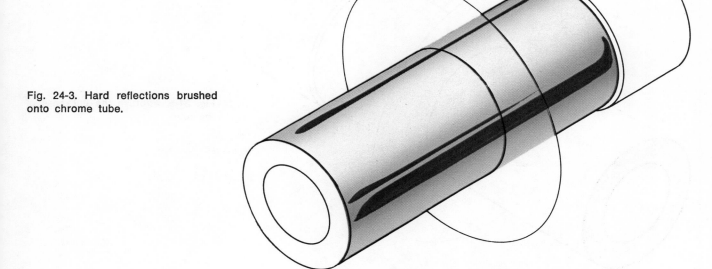

Fig. 24-3. Hard reflections brushed onto chrome tube.

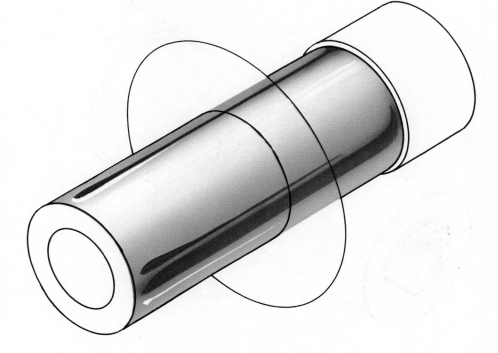

Fig. 24-4. Softened hard reflections/bottom reflection on the chrome tube.

with some ivory black (transparents) in your hand brush, paint a ⅜-inch band ¼ inch up from the bottom of the tube, ending with an upward curve at the far end near the cap, as shown in Fig. 24-3. With the same color in the brush, paint a ¹⁄₃₂-inch band across the top of the tube ⅛ inch down from the top with a broad teardrop shape at the beginning.

Clean your airbrush and using diluted Payne's gray, airbrush over the dark line at the top of the tube, from the cap forward, gradually stopping about halfway (Fig. 24-4). Build the airbrushed areas slowly by airbrushing again slowly, as necessary. Airbrush the Payne's gray softly across the upper edge of the band at the bottom of the tube until the hard line is faded back slightly.

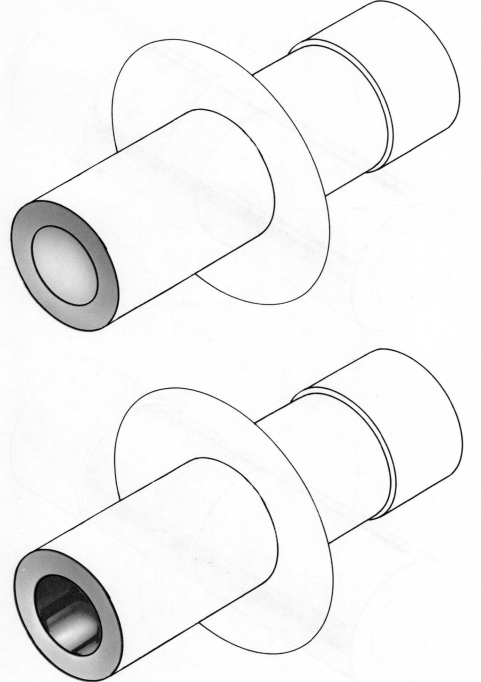

Fig. 24-5. Airbrush the thickness of the tube.

Fig. 24-6. Airbrush to the hole in the tube.

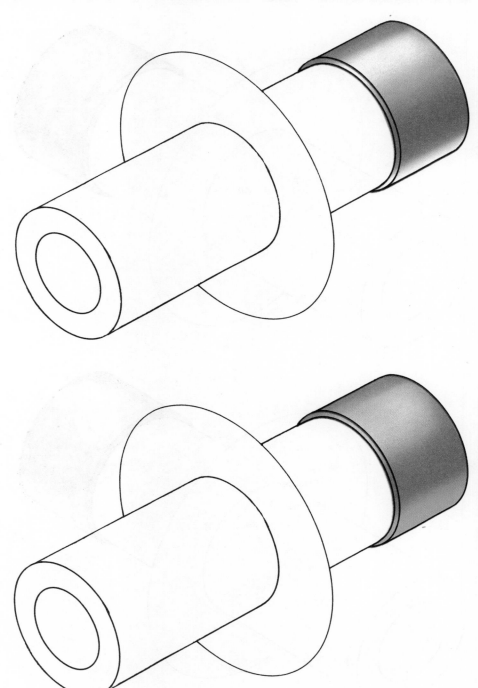

Place a new frisket over the tube thickness and carefully cut and remove that part of the frisket (Fig. 24-5). The thickness area should be airbrushed with the #1 gray and Payne's gray mixture as follows; the edge nearest you should be darkest, fading softly around the thickness toward the back of the tube. Place a frisket over the open end of the tube and carefully cut out only the hole part.

Using the same mixture for the silvery gray, airbrush the upper half of the hole from a solid color at the top and fading halfway down (Fig. 24-6). Also, airbrush a ¼-inch band ¼ inch up from the bottom of the hole. With the hand brush and Payne's gray, brush in a narrow line which flares at the near end, about ¼ inch up from the bottom of the hole. Also brush in a ¼-inch

Fig. 24-7. Airbrush the plastic cap.

Fig. 24-8. Highlight tone on the plastic cap.

band at the top of the hole and ½ inch down. With Payne's gray in the cup, airbrush a gradual tone, full at the top of the hole and gradually fading as you approach the dark band at the top. Build a full-dark tone at the top of the hole. Soften the lower part of the dark band at the bottom of the hole with the same Payne's gray. Remove the frisket; the tube portion is done.

Place a new frisket over the plastic cap; carefully cut and remove the frisket covering the cap (Fig. 24-7). Then, using Flame red from your palette, airbrush the upper area to about ¼ inch down from the top; and starting from the bottom, apply color about two-thirds the distance up, feathering out gradually. Then, using the mixture of Cadmium red and white (pinkish) from your

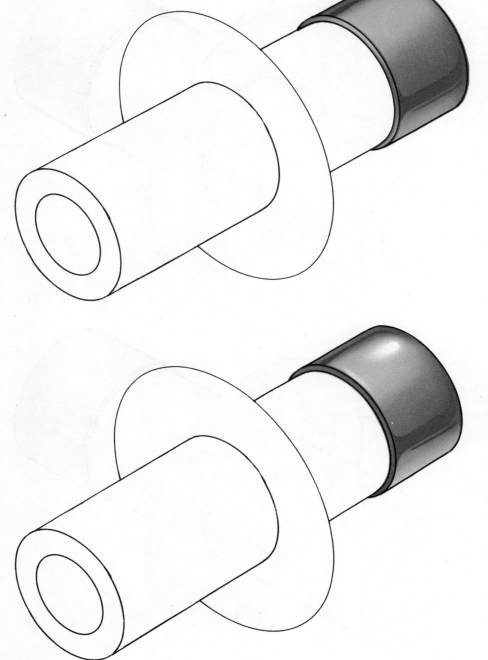

Fig. 24-9. Hard shadows added and softened on the cap.

Fig. 24-10. Plastic cap is highlighted and the thickness painted.

palette, airbrush the highlight area remaining and also a ⅜-inch-wide band at the bottom (Fig. 24-8). Using the hand brush with Red ochre, paint a narrow stripe ⅛ inch down from the top and over the airbrushed Flame red (Fig. 24-9). At the same time, brush in a wider band ¼ inch up from the bottom of the cap, curving upward and narrow at the right-hand end of the cap; these are strong re-

flection areas. The Red ochre bands will now be airbrushed lightly from the rear end toward the middle of the cap with diluted Red ochre. Try to blend softly, not covering the band of color completely; this handling will provide a transparent appearance to the lowlight.

A narrow frisket can be cut for the thickness end of the cap, which will then be airbrushed,

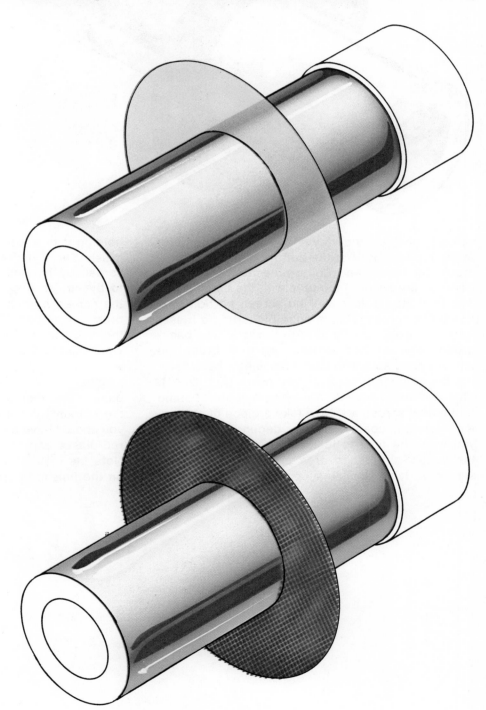

Fig. 24-11. Yellow screen color is airbrushed in.

Fig. 24-12. Dark screen texture is airbrushed in.

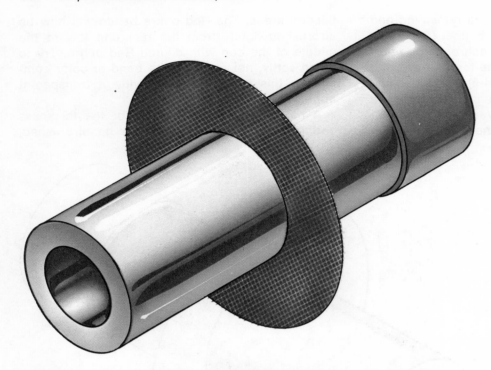

Fig. 24-13. Results of special-effects techniques on finished part.

using Flame red and varying the tone from lighter at the top to darker at the bottom (Fig. 24-10). Remove the frisket and do any necessary touchup between the cap and the tube with the hand brush. The final step is to make the screen portion look like brass screen. This is done by cutting a frisket for the ellipse, making sure to cover all the background and finished airbrush work. Airbrush the entire ellipse area with Cadmium yellow pale, varying the amount of color as you cover (Fig. 24-11). This is done to provide a varying amount of shine to the final screen art. Now take a piece of screening material, coarse or fine, depending on how you want the final to look; place the screen over the yellow airbrushed area and make sure your screen is lying as flat as possible, with weights

holding it in a firm position (Fig. 24-12). Now airbrush Burnt umber from your palette onto the screen by holding the airbrush as perpendicular to the art as possible, so that the underblow on the screen is minimized. Use the same 1-2-3 airbrushing motion (Topic 7), remembering to hold the airbrush in the same vertical position as you work across the screen, until the screen is dark with the Burnt umber color (about four or five passes across the whole screen). Be sure your paint is dry; then carefully remove the weights and the screen from the art. Remove all friskets and you should have a completed chrome tube with the red plastic cap and a brass screen ring around it. Note the results of the special-effects techniques on the finished part (Fig. 24-13).

Topic 25

RENDERINGS ON COLOR BACKGROUNDS

When a color airbrush rendering of a product or mechanical part is to have a flat-colored background, it is usually best to complete the art and place it on a prepared color background (Fig. 25-1). This type of airbrush work is done on a single-weight piece of strathmore paper (kid finish is grained, plate finish is smooth) rubber cemented onto a backing board. You can proceed to airbrush the object without cutting a frisket to protect the background, since you will carefully cut out the finished art; and after removing it from the work board with rubber cement thinner, remount it on the colored background. There are many good colored background papers available at the art store; two of the most commonly used are *Color-Aid* paper and *Color-Vue* paper. The colored background paper is carefully rubber cemented on the back, as is the mount board; when dry you can carefully place the paper on the board, roll it down tightly with the brayer, and coat the whole surface with rubber cement in preparation to remounting the airbrushed art. Before the art can be remounted, however, it should be edge painted with a dark color to minimize the white cut edge. Color and papers are used extensively in preparing color slide art, for displays, and for animated film backgrounds.

Fig. 25-1. Colored art placed on background with more than one color.

Topic 26

REALISTIC RENDERING—CORK
(Lesson 19)

This lesson is another exercise in preparing realistic and effective illustrations. Rendering a cork, make a light pencil drawing of the top of the cork, using a 30° ellipse or similar shape; draw a straight line at each end of the ellipse with the lines slightly inclined toward each other (Fig. 26-1). The lines should be equal in length, approximately the length of the ellipse; then join the two lines at the bottom with a smaller-size ellipse of the same degree curve as the top of the cork. Cut a frisket for the top of the cork; remove that portion and airbrush very lightly with the Burnt sienna and white mixture from your palette. The top of the cork should be darker on the far side, fading gradually toward the front. Then using the hand brush with Burnt umber at any angle across the long side of the top of the cork, brush in some jagged straight lines in a coarse, thick-and-thin manner with some irregular blurbs along the way, as shown in Fig. 26-1. Overspray the entire top with a thin mixture of transparent Sepia, slightly darker toward the back. Clean the airbrush and place clean thin white paint in the cup; cut your

pressure way down for a stipple (or pinch the hose to cut pressure). Proceed to stipple a large white spotting throughout the top of the cork. Now, change to thin Burnt umber in the airbrush cup and also stipple a light, large spotting in an uneven pattern. Do not overstipple; a small amount is sufficient. Remove the frisket on the rest of the cork and replace the frisket on the top of the cork. Again, with the Burnt sienna and white mixture from your palette, airbrush the tone down the left-hand side of the cork—heavily toward the left-hand side and gradually fading as you pass halfway around toward the right; then airbrush the same color on the right-hand side of the cork, fading gradually about one-fourth the distance toward the left-hand side. Overspray the body of the cork with a very thin mixture of transparent Sepia, slightly darker on the left-hand side; be careful not to overdo the sepia tone. Then, with the hand brush and Burnt umber color, pick up the ends of the jagged, irregular lines from the top of the cork; and in a broken intermittent line, following the slight taper on the sides, carry the broken lines down the length of the cork. Stipple the body of the cork with the large thin white stipple and then with the thin Burnt umber stipple, similar to the top of the cork. Remove the frisket and remove any excess rubber cement from the edges of the illustration.

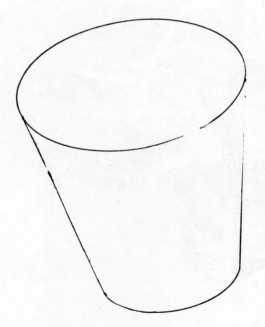

Fig. 26-1. Rendering of a cork.

Topic 27

PORTRAITS IN AIRBRUSH

Rendering a portrait with the airbrush takes a special touch and experience, which can be gained only by practice. Very effective and realistic appearing likenesses can be achieved in this manner. First, of course, a good pencil drawing or tracing of a photograph is necessary, along with perfect control of the airbrush and the correct paint mixture. The paint must be thin and of transparent consistency. You must build your areas gradually so that the skin texture and color do not take on a powdery, ghostly look. Your colors must start from the middle tones to the light tones and detail out with the deep tones. Single source of lighting and perhaps a backlighted color reflection add drama to a portrait, although the normal handling in realistic color also is effective, as shown in the airbrushed portrait of Einstein in Fig. 27-1. Portraiture of famous people and performers is used frequently in posters for displays and motion picture advertisements.

Fig. 27-1. Airbrushed portrait of Einstein.

Topic 28

THE DERRINGER
(Lesson 20)

The line drawing of the Derringer pistol can be traced and transferred to a good illustration board or to a piece of strathmore kid finish, and mounted on a backing board (Fig. 28-1). The colors from your palette to be used in this lesson are the Azure blue and white mixture, white, light gray, medium gray, Payne's gray, and dark gray. Cutting friskets as necessary, all the small exploded parts (Numbers 2 through 8, 10 through 14, and 16 through 21) will be handled generally in the same fashion. The left-hand side will be dark gray (either frisketed and airbrushed or hand brushed), the right-hand side will be medium gray with the highlight portion and curved areas handled in a hard edge, softened with the airbrush, as shown in Fig. 28-2. Holes in the parts and shadow detail

are carefully done with the hand brush and Payne's gray. Edge highlighting is carefully done with the hand brush and light gray paint. The barrel (part #1), the sight, and the top of the lower barrel are hand brushed with a mixture of medium gray darkened with Payne's gray, while the bottom of both upper and lower barrels is a similar toned mixture, darkened additionally with Payne's gray. This area is softened with the airbrushing of dark Azure blue. Payne's gray brushwork just above the reflected area at the bottom of the barrels and in the slot and barrel holes finishes the barrels, with the exception of the connecting bar and the barrel ends, which are handled by brushing medium gray below the highlighted area and on the full edge of the barrels; then it is softened with an airbrush overspray of the Azure blue and white mixture from your palette. The handle (#9), the flat side on the left, is toned with a mixture of Payne's gray and medium gray, similar to the tone on the barrels. The barrel rest will be done in an identical fashion to the barrels, since they are in

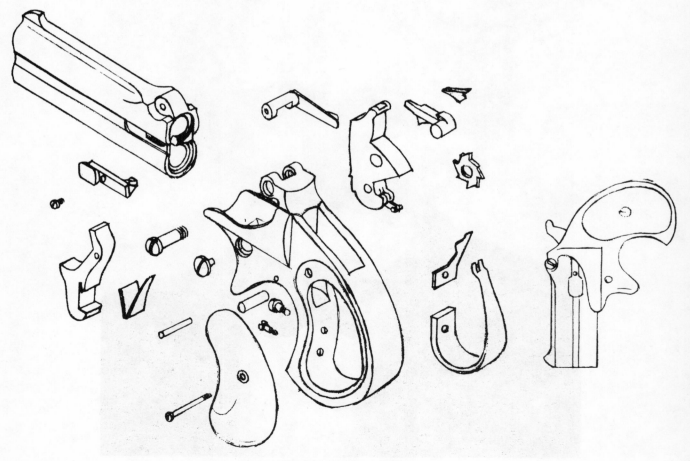

Fig. 28-1. Parts diagram of a Derringer pistol.

the same plane of reflection. The inside of the barrel rest is done with medium gray in a hard manner, softened with an overspray of medium gray. The top of the handle at the clevis that the barrel attaches to is done in the same medium gray and Payne's gray mixture. The back and inside of the handle are hand brushed with Azure blue and white mixture, overblown with the same color to soften the hard reflection and also shadowed at the base of the handle and at the turn of the handle under the connecting pin at the top. A light gray is painted in the insert for the handle cover and for the back half round behind the barrel rest. Again, edge highlighting is done with the light gray and the hand brush. The final part is the mother of pearl (or any other material you may desire) handle cover. First brush some white uneven areas; then soften them with a very small amount of Azure blue and white, which is then overblown with clean white for a translucent appearance. Then, take your medium gray and add just a brush tip of Payne's gray in a thin mixture and, with as fine a spray as possible, crisscross a very controlled area to provide the transparent shadowy effect to the mother of pearl, also adding the soft rounding on the left-hand side of the curved cover. Remove the frisket and do any necessary cleanup handwork.

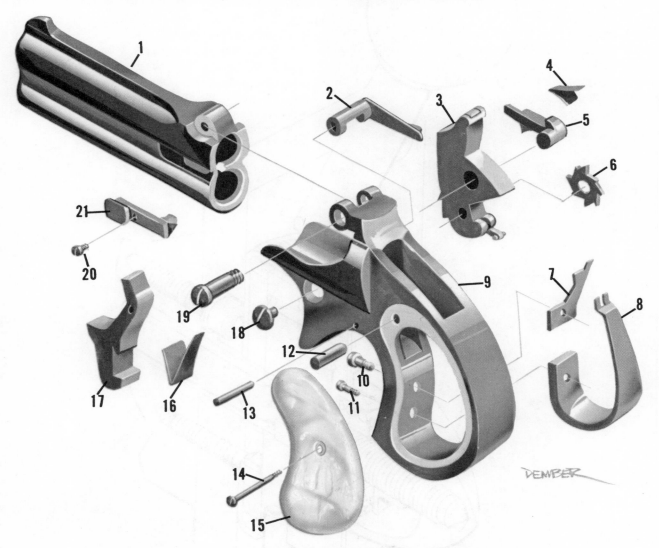

Fig. 28-2. Finished rendering of the Derringer pistol.

Topic 29

RENDERING THE TECHNICAL VALVE—THE CUTAWAY
(Lesson 21)

The step-by-step rendering of a technical cut-away (Figs. 29-1 through 29-5) shows the individual areas in the various steps, with Fig. 29-5 showing all the areas joined in a final result. As in previous lessons, you can make a tracing and transfer it to good illustration board (see Fig. 29-1). Frisket all internal parts and cavities, and render them, as shown in Fig. 29-2, using a medium and dark gray for the pins and threaded bolts, a Burnt sienna and white for the copper pin at the bottom, Cadmium red pale for the control fluid, Cadmium yel-

Fig. 29-1. Line drawing of a technical part.

low deep for the curved scale, and Payne's gray for the cavity areas. This all can be done with one frisket and dry masking. Remove the frisket and carefully cut a new frisket for the external areas shown in Fig. 29-3. The external colors are a medium gray with a touch of Payne's gray mixture for all but the control lever, the center pin, and the retainer screen; these are done in a 50/50 mixture of dark gray and Payne's gray. When completed, remove the old frisket, and place a new frisket on the cutaway section and on the control knob, as shown in Fig. 29-4. The cutaway section is a light gray with a light overblow of Payne's gray at the base and shadow areas. The knob is handled like the hard-effect sphere; starting with the Cadmium yellow deep, airbrush around the

circumference with a heavier spray at the bottom one-third of the sphere. Brush in an irregular crescent shape at the lower right, one-third the distance up the sphere with a Cadmium orange, and also brush in a narrow strip at the upper left-hand edge of the sphere. Soften these areas with an overspray of Cadmium orange, carrying a tone halfway around the bottom of the sphere. Softly airbrush a dark area ¼ inch up from the bottom of the sphere with Burnt umber. Paint in a clean white ball at the highlight area on the sphere, and proceed to soften out the bottom of the highlight spot with *clean* white in your airbrush. Brush in a reflected area at the top left side and at the bottom right side, using Cadmium yellow deep in a narrow line; brush in a dark color under the

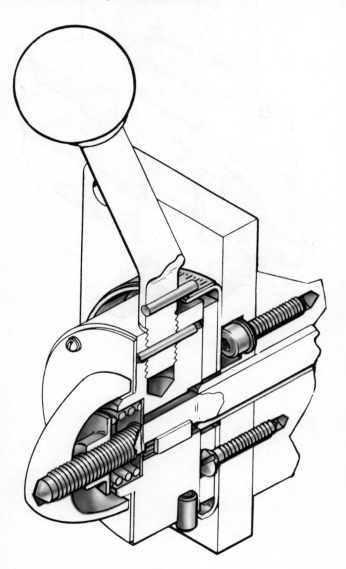

Fig. 29-2. Airbrushed internal area.

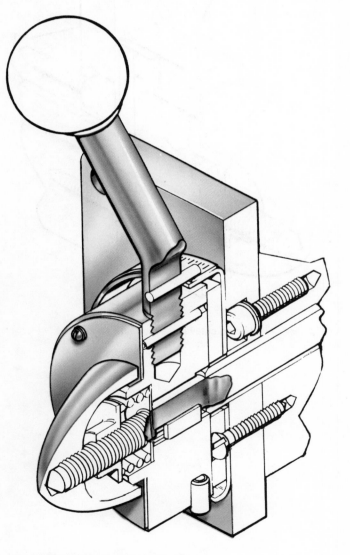

Fig. 29-3. Airbrushed external casing.

spherical knob at the connection point. Remove all friskets and you should have a completed cutaway

valve, as shown in the finished airbrush cutaway in Fig. 29-5.

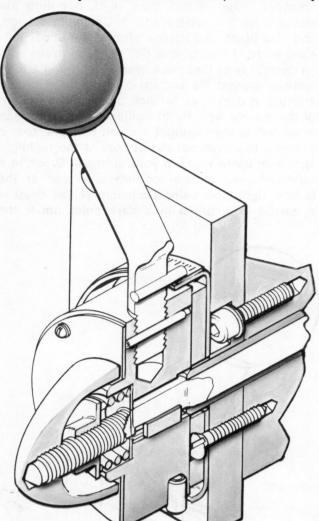

Fig. 29-4. Airbrushed cutaway section and knob.

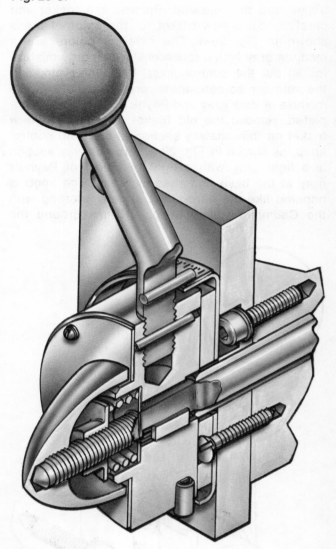

Fig. 29-5. Finished cutaway of valve.

Topic 30

REPRODUCTION—COLOR VS. BLACK AND WHITE

One of the reasons your color palette is so specific in the colors to be used is that all commercial and industrial artwork ultimately will be photographed and reproduced by printing. The colors selected have a more distinct separation in the lens of the fultone and halftone camera. The two charts shown indicate what happens to the basic colors when photographed for black-and-white or reproduction (Figs. 30-1 and 30-2). The charts compare *Color-Aid* papers, airbrush work, transparent and chart tapes, and gray-scale control patch; when photographed, the gray patch must match the gray patch reproduction, for a true representation of all colors. The negative for the black-and-white chart was panchromatic film (pan-

Fig. 30-1. Black-and-white photoprints from color.

Fig. 30-2. Color-scale chart.

chromatic—meaning all color sensitive). Normally, if color will separate well in the black-and-white reproduction, it will hold well in color reproduction.

Also shown is a color/black-and-white slide rule made up of *Color-Aid* papers, paints, and tapes with the actual color on the slide and the black-and-white reproduction of the same colors on the bar (Fig. 30-3). This will provide a quick reference to determine which colors will hold well when next to other colors of similar value. Note that the reds and oranges are close in value and must be separated by making the red darker and the orange lighter, if they are used in close proximity. Similarly, blue/green combinations have the same problems; actually, some of the blues will repro-

duce almost identically to the green of a similar value.

Color coding is in use for industry and the military, to show the operating fluids on technical art. Cutaways and schematic drawings of mechanical parts must show the various operating fluids and, in some instances, the mixing of those fluids to indicate the functioning of the part. The commonly accepted fluid coloring will show red, for fuel; green, for an oxidizer, if the part is to function in a vacuum; orange, for pneumatic fluid or pressure; yellow, for lubricant; a mottled light blue gray/red pink, for hot gases; bright blue, for electrical; and a metallic gray, for the metal casing of the part itself.

Fig. 30-3. Color slide rule.

Topic 31

THE BOOK JACKET
(Lesson 22)

Prepare a book jacket of any design, any letter of the alphabet can be used for its title, in any style, and as many times as you feel necessary; the letter or letters can be used as part of a design (Fig. 31-1). If an illustration is used, it must reflect the letter chosen as the title, for example,

the letter "B"; the illustration can be of a ball, bumblebee, etc. The book jacket must contain at least 50-percent airbrush work. The color and design must carry around the backbone of the book, but do not have to cover the back of the jacket; do not forget to allow 2½ to 3 inches for the flaps to hold the jacket onto the book. Use single-weight strathmore paper, or similar paper, so that it will fold around the book. The finished design can be covered with cellophane and used as a sample of airbrush design work in your portfolio.

Fig. 31-1. Letter in book-jacket design.

Topic 32

RETOUCHING THE COLOR PHOTOGRAPH

Retouching color photographs requires a sense of color matching and a bit of know-how. The normal color print will be 8×10, but on occasion 11×14 prints are required; they both will be handled in a similar manner. First the photograph must be mounted on a firm card stock. You can either dry mount, using dry mount photographic tissue and a hot press, or wet mount, using rubber cement on both the back of the photograph and on the mount board. Permit the rubber cement to dry totally, and carefully center the photograph on the card. Smooth out the photograph with the flat of the hand, making sure to avoid all folds and wrinkles; then roll down firmly with a brayer.

Clean off all the excess rubber cement from around the border and, using saliva or *Energine* cleaner on sterile cotton, carefully wipe down the surface of the photograph; do not rub hard, but keep the cotton substantially moist. At this point, you will note that the photograph will turn predominantly blue. DO NOT PANIC, the blue emulsion is stronger than the other primary colors and comes forth readily. USE CARE WHEN THE EMULSION IS WET. When the surface is dry enough to proceed with the work, it will return to its normal colors. In a like manner, if you do any brushwork on the photograph, the surface may turn bluish; this also will fade when dry. Be especially careful in cutting friskets; keep your cut lines at a minimum and do not bear down on the frisket knife—keep it sharp instead.

The color camera is extremely sensitive and will pick up any marks or blemishes on the surface; therefore, work with a cover sheet and do not mar

Fig. 32-1. Opaque paint on a photograph.

Fig. 32-2. Transparent paint on a photograph.

Fig. 32-3. Black-and-white photograph—before coloring.

Fig. 32-4. Black-and-white photograph—full color.

the surface. For this same reason, your color matching must be accurate and blend gradually with other colors; a harsh blend will show up as just that. If you are working on an acetate overlay to change or blank out a portion of the photograph underneath, you must be careful not to achieve a "powdery look"; again, do not try to cover fast, build your cover with progressive not-too-thick overspray. Keep in mind that when working on an overlay, the density of the acetate itself will change the color underneath to a deeper tone; you can match this tone increase by the addition of a slight amount of transparent black. Grays will not work, since they add a lighter value to the colors. Start by adding fractional amounts of transparent black directly to the color cup. Experience and practice are the best teachers; once you have mastered this technique, it will stay with you. The following information is true of airbrush work on photographs or on renderings:

1. When items or backgrounds are to be changed or removed completely, opaque designers colors must be used (Fig. 32-1).

2. When an object or a background is to be strengthened or intensified, you should use transparent watercolors or watercolor dyes (Fig. 32-2). Occasionally, you will be requested to change color; if the color is such that overspray with a transparent or dye will gain the desired color, you will find it easier than covering with opaques.

An example might be a photograph with an orange or yellow object that is required to be red—by using red transparents or dye, you can keep this fresh actual look of the photograph rather than by reairbrushing with opaques. Note that retouching color photographs is dependent on the type of work and the amount of work to be performed.

Full Color From Black and White (Lesson 23)

There are a number of requests for color photographs when only black-and-white prints are available (Fig. 32-3). This can be accomplished by obtaining a black-and-white glossy print; mount the print and, using masking tape, cover the white border on the photograph. Then, do all the retouching necessary in retouch grays; cut one frisket to cover the background and by using dry masks and Dr. Martin's watercolor dyes, or similar, airbrush sparse color onto the part. If the subject is vibrant and heavy in color, you may have to use transparent watercolors to obtain coverage. Do not use a great variety of color. Normally, a suggestion of color by highlight and lowlight will be sufficient. Remove the frisket and cut a new frisket to cover the object. Airbrush an opaque background color to enhance the object; when separated and printed, it will appear quite similar to a full-color photograph (Fig. 32-4). If your photograph has a background with detail to be retained, the first procedure of using dyes and transparents will then prevail. Remove friskets and masking tape and do any necessary touchup. If it is desired to "pop out" a certain portion of the photograph in color, you may have to use opaque colors and reflected tones. Compare the black-and-white and full-color photographs in Figs. 32-3 and 32-4.

Topic 33

VIGNETTE AND GHOSTING EFFECTS

Vignette effects are called for frequently; the vignette is a fade-out to nothingness around the object (Fig. 33-1). Starting with a color or black-and-white photograph of a building (see Fig. 33-1A), the photograph is mounted on a card and, depending on whether you want to fade into a solid color or to a white background, you must mask the edges of the photograph with tape and airbrush your opaque color toward the taped edges

(A) Full photograph of a building complex.

(B) Full photograph with background dropped back.

Fig. 33-1. Vignette effects.

Fig. 33-2. Ghosted part.

—away from the building in the photograph to keep the overblow in that area at a minimum (see Fig. 33-1B). If you were to try removing the overblow from the building area, you would obtain a hard edge wherever you stopped the removal process; this is highly undesirable.

Ghosting effects are accomplished in much the same manner as the original airbrush work, with one great difference—the color must have a transparent look (Fig. 33-2). This is accomplished by airbrushing the top surface or the exterior shape over the inner part, heavy on the edges, and quickly fading over the internal part. Make sure you do *all* the highlighting, and work the inner part *before* airbrushing the transparent effect.

Making a Horizontal Photograph into a Vertical Photograph or Vice Versa

Extending backgrounds is accomplished by obtaining a new photographic print of a horizontal or vertical picture in the center of the larger piece of photographic paper (color or black-and-white) and by airbrushing the background either vertically or horizontally to fill the required dimen-

sions (Fig. 33-3). This is done in this manner, since there is no way to successfully lose the hard cut edge of a photograph. The extending also can be done by mounting the original photograph in the center of an oversize board and placing an oversize sheet of acetate (do not touch the acetate surface) over the photograph. Thin cotton gloves should be used when working on acetate. Use masking tape and paper to mask the background around the required shape. Then, airbrush in the background detail, matching the base colors and values as closely as possible.

Color Work on Overlays (Lesson 24)

Obtain a photograph (black-and-white or color) and mount it as described above. For the first effort of this kind, the simpler the photograph, the better it is. When airbrushing an extended background on an acetate overlay, build the background gradually, trying not to excessively overblow the area of the actual photograph. Use extreme care in handling the acetate overlays to minimize fingerprints.

(A) Before extending background.

(B) After extending background horizontally.

Fig. 33-3. Extending background on color photograph.

Topic 34

PHOTOGRAPH ON RENDERED BACKGROUND

This combination can be used with good results in both black-and-white or color. The use of an actual photograph of an object placed on a rendered background produces a variety of effects that could not be arrived at normally. For example, a photograph of a newly designed rocket-powered vehicle, shown on the Moon's surface, is required for a news release. All that is available is a photograph of the model of that rocket vehicle. With minor retouching to clean up the photograph of the model, the rocket vehicle is carefully cut out of the photograph; it is edge painted to match the background of the Moon's surface, which is rendered with brush and airbrush (Fig. 34-1). The photograph is then carefully mounted onto the rendered background; a few light shadows and reflections are painted off the vehicle's landing pods, and you have a realistic artist's concept of a newly designed rocket vehicle landed on the surface of the Moon.

Fig. 34-1. Photograph on rendered background.

Topic 35

AIRBRUSH RENDERING ON PHOTOGRAPHIC BACKGROUND

Conversely, the aforementioned technique can be reversed, taking a similar example; it is desir-able to have a newly designed airplane shown flying in a sky with fluffy clouds. The photograph of the cloudy sky exists, but only drawings exist of the new airplane. A rendering of matching color or values is made of the aircraft, which is then cut out, edge painted, and mounted on the actual photograph; the result is truly realistic (Fig. 35-1).

Fig. 35-1. Airbrush rendering of an airplane on a photographic background.

Topic 36

COLOR PHOTOGRAPHIC PORTRAIT RETOUCHING

This technique takes a special insight into keeping the photographic portraits alive in appearance. You may be called upon to remove one of two persons from a photograph (Fig. 36-1). The removal operation may not be a difficult problem, since you are matching background color and materials (Fig. 36-1B). However, if the face of the remaining person was partially overlapped by the person removed, the rebuilt face must not look powdery or corpselike. To accomplish this end, you must always airbrush the deeper colors over the lighter colors; you may occasionally have to use a transparent watercolor Sepia or thin black overspray to match the tonal depth of the color photograph. The key to this type of work is in using a very thin paint mixture and overworking, rather than covering quickly, since the fast method powders the paint and gives a grainy appearance to the work.

(A) Photograph with two persons in background.

(B) One person removed and background changed.

Fig. 36-1. Retouching color photograph portrait.

Topic 37

PRESENTATION SLIDES

The airbrush is used extensively in the preparation of art for slide presentations and strip-film presentations in marketing and educational programs. Various sizes of slides and projectionable materials are used. (Fig. 37-1).

1. 35mm slides ($\frac{7}{8} \times 1\frac{3}{8}$)
2. Super slides (square) (2×2)
3. Vue-graphs (transparencies) (8×10)
4. Lantern slides ($3\frac{1}{4} \times 4\frac{1}{4}$)

All projectionables are generally prepared in the same fashion, but backgrounds must have bleed to prevent haloing when final slides are photographed.

Normal preparation would utilize color backgrounds, such as *Color-Aid, Color-Vue, Pantone* sheets, solid-color *Zipatone,* etc. Combinations cover an illustration of some kind (cartoon, illustrative, technical, product, and photographic—or line art) with a title, callouts, descriptive words, or merely an attention getter. Two colors can be used to separate the illustration and the wordage; they can be complementary or analogous colors, but they should be subdued and light enough for reading matter to be legible. The listings or callouts should be press-down transfer letters or words on clear-film overlays to minimize cutouts. If cutouts of words are to be used, they should be cut out perfectly parallel on opposite sides to look clean; a piece of transparent *Zipatone* in a light color should be pressed down over the copy. If dark backgrounds are used, a material is available to provide an extremely professional appearance to the title and copy. This material is called *Color-Key;* it is manufactured by the 3M company. The white opaque is most generally used, although it is available in a variety of transparent and opaque colors. Color keys may be made with your own lighting equipment, after a negative of your copy is obtained. Information pertaining to this process may be found at any photographic supply house.

One additional technique of presentation is the split-screen; this utilizes two 35mm or two super slides made from one piece of art twice the length of a single slide. These are projected side-by-side with the right- and left-hand sides coming together at the center to form one large extended projected image on the screen. This is accomplished when two projectors are used on a large screen for presentation purposes. The 35mm slide requires a slide projector and a darkened room, as do the super slide and the lantern slide. The 35mm and super slides are small and easily transported. The lantern slide is a larger slide and produces better rendition; but both the slides and the projector are heavy and large.

Vue-graphs and transparencies require overhead projectors, some of which are portable and some are not. They produce a good image and the presentor faces his audience with the house lights turned on.

Fig. 37-1. Shapes of projectionable materials.

Topic 38

FALSE-COLOR PROCESS PREPARATION

Generally, a full-color piece of art is color-separated by lithographic camera and filters, color-corrected, and run on a press for reproduction copies. This process is excellent for obtaining full-color reproductions. On occasion, a request for false full-color, or three-color process is received. Color may not be available, or cost may be a factor; however, the final effect is different from full-color. Thin cotton gloves should be used for work on acetate in preparing this work.

The airbrush can be used to effect a full-color piece of art for reproduction. By starting with a black-and-white piece of art or photograph (this is done mostly with artwork), you can prepare black-and-white overlays to be copied photographically for process yellow, process red, and cyan blue inks which will overprint the black-and-white art, producing the appearance of full-color reproduction (Fig. 38-1).

This process, of course, requires experience and a knowledge of color-to-gray transition. The use of a percentage-gray scale to determine the amount of gray for that percentage of color will help. The *Coloron,* manufactured by the Delta Brush Corp., New York, is one type of scale (Fig. 38-2). It contains a set of eleven permanent, transparent sheets printed with a series of graduated panels from a 10-percent tint to a solid of black ink and ten other color inks. These same sheets show a line of copy in solid color overprinting each percentage panel, with the same copy reversed out of each of the percentage panels and the copy itself printed in each of the percents from 10-percent through solid. These sheets will give truer service, if the actual stock to be printed is used for matching colors to grays, since paper stock does affect the inks printed.

Use of the black percentage sheet will predetermine what gray paint to use for a result of the percentage of color desired. We would use only the process yellow, process red, and process blue in combination with the black to predetermine the tones desired. For example, to determine what grays must be used to produce an orange, lay the sheets over each other in a printing sequence (1—yellow; 2—red; 3—blue) and vary the percentages (lay the 80-percent yellow first; then 20-percent red; and, if you wish to deepen the orange, add 10-percent blue or 30-percent red); the corresponding percentage grays shown on the black scale are the grays you will airbrush on each of the progressive acetate sheets to arrive at that orange when finally printed. By using the different combination colors or by leaving one of the color scales out of an area entirely, you can achieve all the possible printed colors. Before continuing, it might help to mark a sheet of paper for quick reference with the percentages of the various tones and colors you want to use.

Remember, the percentages of yellow you want should appear in the corresponding value of grays on your yellow overlay only, as should the overprint percentages of red appear on the red overlay only and the blue on the blue overlay only, while the black will be taken care of by the low-contrast black-and-white base art or print.

To prepare an actual piece of black-and-white art or photograph for false-color process, you must start with a low-contrast black-and-white piece of art or a photographic matte print which is mounted to a board, leaving a border of about 1 inch all around. One bullseye register mark is placed on each side and one mark at the bottom of the board, outside the art area. Three sheets of *absolutely clean,* untouched 0.005-thickness acetate must be used. The first sheet is placed over the art and taped at the top; a matched set of bullseye registers is placed over the base set. Mark this sheet "yellow" at the bottom, outside the art area. The art area is then masked carefully with tape and paper around the outside area. We are now ready to prepare the yellow plate. Using the grays to correspond to the depth of yellow and using dry-mask cutouts (there is no residue to remove when using dry masks), complete the yellow overlay. When all the airbrush work is completed, carefully remove all masks; spray a fine fixative coat over the entire plate for protection purposes. Be sure the fixative coat is dry before taping the second overlay in place, setting the bullseye registry marks, and masking the border. In a like manner, being extremely careful of the acetate surface, complete the red overlay and continue with the blue overlay. When the finished overlay art is delivered to the client, he should be cautioned as to the fragility of the art.

(A) Preparing overlays.

(B) Progressive proofs.

Fig. 38-1. False-color process preparation.

Fig. 38-2. Coloron scales.

Topic 39

AIRBRUSH WORK IN MOTION PICTURE ANIMATION

Motion picture animation requires close coordination between writer/director and animator/artist. A rough draft or outline of the script and an approximate amount of animation artwork is determined first. At this time, the style and treatment are established. The animator makes an in-depth study of the subject matter, and the final script is then broken down with a definite succession of events established. The next step is the preparation of a storyboard.

The Storyboard

A storyboard is a pictorial sequence of the script, including all animated scenes with indication of full or limited animation (Fig. 39-1). When the storyboard is approved, the animator makes rough pencil layouts of all base art. Separate folders are created for each individual scene. An animator usually handles an entire scene; he develops the pencil roughs into a tight pencil layout and, upon approval, the pencils go into final-base

Fig. 39-1. A storyboard.

art (Fig. 39-2). A master sheet is prepared of all action and art for each scene. The narration track is then broken down into feet and frames, action words are redlined, and the frame count is entered on the master sheet.

Fig. 39-2. Rough sketches for animation.

Cel Work

Animation for motion picture work normally requires airbrush on backgrounds and on *cels*. The cel work is very exacting and requires the use of thin cotton gloves while working on the cels to minimize finger marks, scratches, etc. It takes a number of cels to accomplish a smooth transition of action; and each cel must be keyed both to the cel before and the cel after, plus matching the background positioning art at all times (Fig. 39-3). A cel is a sheet of acetate of a specific thickness (0.005 in.) and size.

The Pegboard

Accurate placement at all times is accomplished by use of a pegboard, which is an extremely accurate metal strip with two projecting slots in a straight line and a round peg in the center; all the paper cels, background art, and transparent cels are prepunched with this slot-peg-slot pattern in a specific placement which is universal throughout the animation industry, allowing camera work/artwork to place identically. All the work must be done while locked in this position, so that the

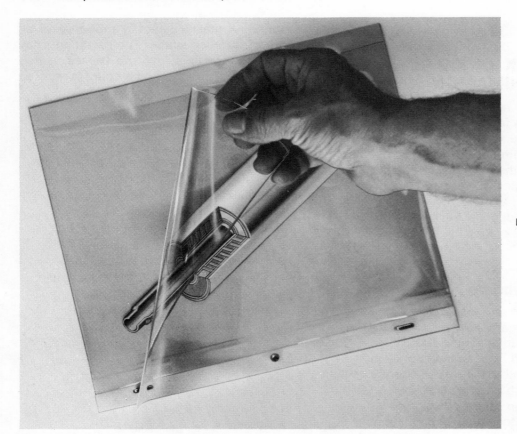

Fig. 39-3. Cels for background.

Fig. 39-4. Pegboard with a cel.

Fig. 39-5. Inked cels.

camera can hold a true lineup (Fig. 39-4). If this procedure is not followed closely, jumping and sliding occur on the screen. All presketches also must be done while locked on the pegboard; this assures that all action originates from the first sketch. Flipping the progressive sheets back and forth allows a motion check while actually sketching the pencil roughs.

Inking

Some final cel work requires inking; these inked cels are back painted with flat colors in sequences of action and placed over painted backgrounds, creating the animated cartoons with which moviegoers are familiar (Fig. 39-5). Other animated films are used for training, marketing, instruction, and advertising purposes. The combination of animation and live-action motion pictures also is used frequently. You already have been exposed to airbrush work on acetate cels in previous lessons; this work is quite similar, with the exception that the work is much more detailed for animation, in addition to being in full color. As each cel is completed, it is keyed to the background, marked in order from the master sheet for the camera, and kept in its own scene folder.

Cel Colors

Colors used for airbrush animation work are produced by the Cartoon Colour Company of Culver City, California (Fig. 39-6). These are made in two mediums: (1) "regular cartoon colour," which is rewettable and can be safely used in the airbrush; and (2) cel-vinyl colors, which adhere to acetate, glass, foil, and plastics, and are not recommended for airbrush use (both are made up in a great variety of color and hue to match any color sequencing).

Field Sizes

Animation work is prepared to specified field sizes—these are always horizontal to match the 16mm or 35mm film sizes. A prepunched pegboard

Fig. 39-6. Cartoon colors on swatches.

cel is marked with fields ranging from 4-field size to a 12-field size; 8- and 12-field sizes are most commonly used (Fig. 39-7). Camera directions are given in compass readings (North-South-East-West) to assume correct direction of camera travel. Specialized fields in animation art cover the background artist, the animator, and the inker.

Background Work

Background work may range from a stylized live drawing to a full-color, in-depth rendering; and it is an integral part of the overall picture. Background work is generally the most interesting, with airbrush work on cels a close second.

Scratch-Offs

Scratch-offs are created to give the illusion of something building up on the screen or something diminishing on the screen. It is accomplished by the airbrush work being done completely on a cel; a little footage is shot, some of the material is removed from the cel, and some more footage is run until all the material is gradually "scratched-off." The sequence is run backward and a buildup appears on the screen; or if the sequence is run forward, the buildup disappears from the screen.

Add-On Art

Some of the more intricate art may be done on a single-weight strathmore paper and edge painted to match the background color; then it is carefully adhered to the cel with all additional action on progressive cels (Fig. 39-8). Cel work should not exceed five cels in depth, since the color depth will increase too greatly. The series of cels shows the progressive buildup of action; some of the action is animated on cels, and some is airbrushed

Fig. 39-7. Field sizes.

Fig. 39–8. Work on strathmore paper.

on single-weight strathmore and mounted on cels —all are pegboard punched for the sake of accuracy.

Film Titling

Titling for animated films is done by hot press on a transparent cel; this involves a metal type char- acter, heated and impressed with the desired color onto a transparent cel in the exact required posi- tion. The titling preparation also can be accom- plished by the color-key process (Fig. 39-9); white, black, and many colors are available, in any com- bination. The foregoing chapter is only an intro- duction to film animation; it is a complete field of its own.

Fig. 39-9. Overlay with white color key.

Glossary of Airbrushing Terms

Backlighting Preparing art with an imaginary light from behind the object in the foreground.

Binder An additive included in paints to hold the pigments of color together.

Brayer A roller with handle, used to mount photographs and artwork onto board or card stock.

Bridge Usually, a ruler or straightedge upon which the ferrule of the brush is rested to guide the brushwork necessary to highlight and low-light artwork.

Bullseye A crisscross of two right-angled lines used to register overlays in an alignment with base art and progressive overlays.

Cel An overlay acetate or paper aligned with the base art, usually referred to in animation sequencing.

Clevis A double-eared fitting similar to the common hinge within which a single-eared fitting is placed to form a pivot.

Drybrush A manner of brushwork whereby the paint is used in a thickened consistency effecting a textured coverage of paint.

Cutaway A drawing or rendering made of a part, building, or object revealing the internal structure.

Dry mask A method of masking or frisketing a photograph or piece of art by means of cut-out paper, card or acetate, or other overlay material.

Emulsion The delicate, light-sensitive coating applied to film or photographic paper.

Frisket knife An *Exacto* type of handle and small blade used for cutting friskets and dry masks.

Frisket paper A thin transparent paper used for masking when coated with rubber cement in preparation for airbrush work.

Fultone A photograph that is continuous tone; it has the full values of grays and black.

Gesso A plaster-like art media used for building heavy textures before airbrushing or painting.

Ghosting The technique of making a surface transparent, so that the internal parts can be seen through the exterior case and the exterior case itself also can be seen.

Gouache (gwash) Name given to opaque paints.

Halftone A photograph that has been rephotographed through a photographic screen to obtain a dot pattern in preparation for reproduction by printing, since any continuous tone must be broken up into percentages of black-and-white prior to printing.

Highlight	A section or area that receives direct lighting and is, therefore, the lightest part of the illustration or photograph.
Isometric	A perspective view of an object that is 35°16′ actually giving a three-quarter view of an object.
Light source	A source of an imaginary single-point light giving a highlight and shadow area to a subject.
Lowlight	The shadow portion of an object.
Media	The material used in producing an illustration, such as oil paint, charcoal, water paint, pencil, etc.
Moiré	A diamond-like pattern formed by rephotographing an already screened halftone photograph.
Montage	A single unit made up of a number of smaller units. Example: one large photograph made up of many small photographs. Montages are made up of regular-shaped photographs or irregularly shaped overlapping photographs.
Opaque	Material that has full covering qualities, such as paint used in the airbrush, to completely cover an existing object.
Overspray	That amount of paint that is airbrushed outside a frisket, making a hard edged pattern on the subject.
Panchromatic	In reference to photographic processes, it is film or photographic paper that is sensitive to all colors.
Pigment	That portion of paint that provides the color. This, in combination with a binder, forms the paints that you use.
Reamer	A long flat-pointed needle similar to the airbrush needle; used to clean the airbrush tip, cup, and mixing chamber.
Reflected light	That light which bounces off the base and is reflected back onto the object, aiding in rounding and shaping the subject.
Residual color	The amount of dried color that can remain in the color cup or on the needle if the airbrush is not cleaned properly.
Spatter	A large spitting of droplets of paint from the airbrush tip formed by liquid paint buillding up on the needle and then being thrown off the needle by released air.
Stencil	A dry mask cut to represent a portion of a figure, shape, or letter to be reused on progressive illustrations.
Stipple	A controlled coarse spray of paint used in obtaining grainy effects for textured materials. This is arrived at by reducing the air pressure in the airbrush and thickening the consistency of paint in the color cup.
Underspray	When using dry masks or when a frisket is not completely flat, the airbrush spray may crawl under that mask in an area where it is not wanted.
Vignette	An effect obtained by airbrushing gradually away from an object to ultimately blend away from the object to an absolute-white background.
Wipe-off	The technique of using cotton to remove airbrush spray from an area where it is not desired.

Index